By a Maine River
A Year of Looking Closely

By Thomas Mark Szelog and Lee Ann Szelog

Photographs by Thomas Mark Szelog

Down East

Text © by Thomas Mark Szelog and Lee Ann Szelog. Photographs © by Thomas Mark Szelog.
All rights reserved.
ISBN (13-digit): 978-0-89272-780-3

LIBRARY OF CONGRESS CATALOGING-IN-PUBLICATION DATA

Szelog, Thomas Mark.
By a Maine river : a year of looking closely / by Thomas Mark Szelog and
Lee Ann Szelog ; photographs by Thomas Mark Szelog ; foreword by Richard Grant. — 1st ed.
p. cm.
ISBN 978-0-89272-780-3 (trade hardcover : alk. paper)
1. Nature photography—Maine. 2. Wildlife photography—Maine. 3. Szelog,
Thomas Mark. I. Szelog, Lee Ann. II. Title.
TR721.S94 2008
770.9741—dc22
[B]
 2008015162

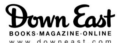

Down East
BOOKS·MAGAZINE·ONLINE
www.downeast.com

Design by The Roxmont Group
Printed in China

5 4 3 2 1

Distributed to the trade by National Book Network

foreword

By a Maine River is, on the simplest level, a visual journal: twelve months in Maine as recorded by a veteran photographer in what he diffidently calls "my own backyard." But of course the story goes deeper than that.

When Thomas Mark Szelog set out to capture one lasting image per week, winter through summer and back again, on his semi-wild, seventy-acre spread in the town of Whitefield, he wasn't just taking on a singular artistic challenge. He was also joining a distinct and distinguished Maine tradition that stretches (at least) back to Thoreau's *The Maine Woods* and marches on through such classics as Louise Rich's *We Took to the Woods*, Scott and Helen Nearing's *Living the Good Life*, Bernd Heinrich's *A Year in the Maine Woods*, and Robert Kimber's *Living Wild and Domestic*.

"Do you people get that way from living here, or were you all peculiar to start with?" Rich was asked once after decamping to her lakeside cottage. We smile in part because it's not such an easy question to answer. Certainly the character of Maine—rugged and raw and still remarkably unspoiled—exerts a marked influence on many of us who settle here. But by the same token, this place has always attracted different-drummer types. Szelog himself, as some readers will recall, published an earlier account of his fourteen years living in a real lighthouse. Hunkering down in the woods with a camera in subzero temperatures, hoping something interesting will pop up, may seem like a quixotic undertaking, but hardly more so than the odd projects of Heinrich or Thoreau or,

for that matter, E.B. White. We're all a bit eccentric here, and sometimes good things come of it.

What's perhaps most remarkable about *By a Maine River*—and you get a hint of it from the quietness of the title—is that its setting and its scope are actually quite modest. Whitefield is not the Great North Woods. As Szelog acknowledges, "the area . . . is not a wilderness and has not been so for centuries." The images here were captured in an ordinary sort of Maine landscape perhaps a baker's-dozen miles from the State House in Augusta. They present us rather often with subjects that are daily fare even for town dwellers: gray squirrels, white birches, rain-flecked lily pads, a half-moon squinting through spruces, a bird's nest clinging to bare twigs.

Then suddenly, on a day like any other, something extraordinary will appear. A goshawk in rare close-up, pale wings just furling. A snake skin snagged by British soldier lichen. A beaver standing on its hind legs, forepaws deftly flexing a tender branch.

These photographs—no less than Thoreau's effort to precisely convey the sound of wind rocking old trees, or Rich's account of a walk through the winter woods—speak to us so evocatively not because of any intrinsic drama, but because they feel so authentic, so unmediated, so first-hand. They invite us to join in an intimate communion with the Maine countryside—to return to a garden that has not yet been lost.

—Richard Grant

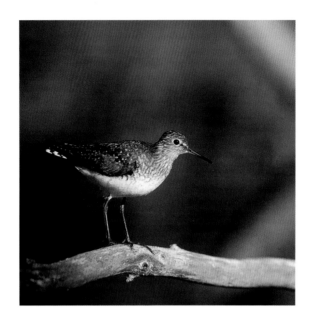

Dedicated in memory of Arthur O. Guesman
A wonderful father, father-in-law,
storyteller, world traveler, animal lover,
mentor, professor, golf coach, epicure,
Civil War scholar, gardener,
Yankees fan (his only fault),
and he loved his own backyard

introduction

Fading concentric rings from a soft rain mark the surface of nearby Bear Pond. Three red squirrels whimsically pursue each other through the forest duff. A flock of black-capped chickadees flutters from tree limb to tree limb. Using its diminutive but sturdy legs, a white-breasted nuthatch defies gravity to ascend the trunk of a white pine. The rain does not bother the animals as they scurry about in their daily quest for sustenance.

On other days, flocks of turkeys, families of white-tailed deer, even an elusive bobcat may wander near my cabin home, from which I have an enviable and inspirational view of Maine's forested landscape as I sit at my desk putting the final touches on this book. Ironically, with all the captivating wildlife around me, of necessity, I find myself working indoors rather than spending a contemplative day exploring and photographing the natural environment that surrounds my home.

In today's world, we often seek an escape from our chaotic lives and frequently have a need to visit exotic, far-off places to find tranquility. Through books, television, and movies, we are inundated with the physical splendor of distant locales, strengthening the belief that we must travel to these places to experience the natural world's radiance. We grow accustomed to our environment and don't see the marvels that surround us each day. There is a complex, mysterious, and stirring world waiting to be visited without having to travel beyond our backyards. *By a Maine River* displays images of the treasures I found by simply venturing into my own backyard—the forest—during a year-long exploration of the seventy acres surrounding Bear Brook Cabin, my log home, in Whitefield, Maine.

I photographed my property's flora and fauna for a full calendar year, using the woods, river, and wetlands as my studio. Venturing no farther than my seventy acres, I attempted to create a body of work revealing the beauty and wonder of the Maine woods. My workweek was Monday through Sunday, and during each of these weeks I challenged myself to create at least one compelling image from the opportunities presented. Much of my time was spent sitting in a camouflaged blind, waiting for wildlife to venture within unobstructed camera range. I used a low-key method to photograph wildlife; by doing so, I kept my intrusion into their lives to a minimum. My desire to allow wildlife the freedom and peace to move through their natural world was a priority. Occasionally, I created the best images early in the week. Often, I needed all seven days before shooting a single frame of film. My time was managed by Mother Nature.

I am proud to say that my photographs are not computer manipulated. Using the finest 35mm transparency films, I worked to capture the unaltered grandeur of the environment. The photographs are not always "clean": they may have brush and tree obstructions, and, in a few, the composition could have been different. These images are the results of the snap decisions made mostly from fleeting glimpses of wildlife. I had no second chances. For

example, the coyote image from January 26 was created with less than five seconds of opportunity. Before I could create another photograph and/or adjust exposure and composition, the coyote fled into the adjacent woods. You are seeing the images just as I did through my viewfinder.

My personal Maine river, the East Branch of the Eastern River, flows freely in seductive curves a quarter mile from my cabin. The area surrounding the river is not a wilderness and has not been so for centuries. But it is a world rarely traveled. There are no grand vistas to draw tourists. Indeed, this ordinary terrain is similar to that which can be found throughout much of northern New England. It is a world of mixed forest, river bottomlands, small swamp pools, marshes, and beaver ponds. At first glance, this composite of trees and water appears unremarkable. But a closer look suggests that its subdued riches provide critical habitat for a wealth of plants and animals and offer, as well, a trove of discoveries for those who seek them; otters slide down slippery river banks, great horned owls hunt among the maze of tree trunks, and Maine's majestic moose travel the river highway. The environment is thick with vegetation, often damp, always difficult to traverse. A few makeshift trails allow for ease of travel in some portions, but for the most part, bushwhacking is necessary. The river is lined with layers of woody plant life: it is almost unreachable except for areas where beavers have thinned the woods and undergrowth. I gave my own names to natural features, and they guided me through the woodland maze: Bugaboo Creek, Bear Pond, Coyote Trail, and Otter Valley became familiar terms in my household.

My wife, Lee Ann, and I discovered this land in 1995, when we were living at Marshall Point Light in Port Clyde, Maine. Although we were residing in our dream home (an authentic operating lighthouse), which is documented in our first book, *Our Point of View: Fourteen Years at a Maine Lighthouse*, there was another dwelling we visualized owning. We began looking for the perfect piece of property on which to build our next home, a log cabin in the Maine woods. We searched much of the state, hoping to find just the right acreage, complete with woods, beaver dams, streams, ponds, and an abundance of wildlife. What we found in Whitefield was beyond our wildest hopes.

Our first visit in November 1995 was on a cold, raw day. The soft, unfrozen ground had a fresh layer of snow, creating less than ideal conditions to walk the property. Nevertheless, we explored the acreage, and with each step we felt as if we were home. It was the land we had envisioned. The road frontage was singular, with a large granite ledge providing almost fortress-like protection; old stone walls were scattered over the property; and overgrown logging roads provided ample trails for exploration. During one visit, we walked several hundred yards down a logging road that branched from the main road and discovered a pond (now known as Bear Pond), next to which was a small patch of cleared land, the precise spot we selected for our cabin.

We purchased the land in 1996 and visited it from time to time while we still lived at Marshall Point Light. We often walked on the property and enjoyed picnics at the edge of Bear Pond. We camped one night near the home site, listening to howling coyotes, hooting owls, and snorting deer, all of which were close to our tent and kept us alert and awake all night. In the late 1990s, we began researching log cabin suppliers, builders, designers, and costs, along with numerous other details. We still weren't ready to depart our beloved lighthouse, but with each bit of research we completed for the cabin, we became more excited about fulfilling our dream of living in yet another quintessential Maine home.

On December 6, 2002, my birthday, Lee Ann and I moved into our new home. A rather appropriate birthday gift because I had fantasized about living in a log cabin since age ten. When building our modest home, we wanted to ensure that the structure had a minimal impact on the land and wildlife, therefore the footprint of the cabin is small. We enjoy our land daily, snowshoeing it in the winter and hiking it during the summer. We play hockey and Frisbee with our two chocolate Labrador retrievers, Bear and Moose, on Bear Pond during the winter. Bear took his first swim in our Maine river when he was a pup.

I learned more about the land, and about myself, during the year of this undertaking than I would have thought possible. Spending fifty-three weeks in the forest enhanced my appreciation of it evermore. Immersing myself in the land for such a length of time, through photography, was destiny. Nature called me. She offered her details in the grace of a shed turkey feather, her elegance in the ice crystals that formed overnight on undergrowth, and her complexities in the elements and seasons. I greeted every day with passion, eager to search a piece of heaven, never knowing what I would behold. I explored my property with the enthusiasm and zest of an adventurer. I was aware from the beginning that this project was different from anything I had done before. I awakened each morning anxious to experience the new day's sights, sounds, odors, and the emotions they generated within me as I faced the rising sun filtering through the trees or the bitter but exhilaratingly cold temperatures. I often felt like a child experiencing things for the first time. The forest inspired me. In it I found peace.

My seventy acres is a place unto itself. Although small by most standards, it is large enough to hold daily surprises. I worked in Mother Nature's studio for months without seeing another person. The wondrous solitude overwhelmed my senses. Neither sight nor sound of human intrusion marred the enchantment. I was alone for a year in the forest, but I was not lonely. The environment was alive with creatures whose presence negated the possibility of loneliness.

Some of the notes for this book were "scribbled" in my mind while sitting in a photography blind trying to keep from freezing in temperatures as low as minus twenty-four degrees Fahrenheit. Although I sat nearly motionless hour after hour, day after day, month after month waiting for fleeting opportunities, there were many periods when I didn't obtain an acceptable image until the week's last light. The *worst* part of this project was sitting in my blind on a five-gallon bucket for hours in subzero temperatures made harsher by a biting wind chill; on the other hand, the *best* part of this project was sitting in my blind on a five-gallon bucket. . . . Either way, it beats being in an office.

By July, the challenge was beginning to take its toll on me. One would think the conditions would improve during the summer, but, quite the contrary, they worsened. Summer's thick vegetation hampered my efforts. Visibility was down to only a few feet, and the mechanical limits of photographing were frustrating. Even the usual open spaces along the river, ponds, and wetlands were saturated with tall, thick growth. My surroundings were transformed into a jungle, complete with heat, humidity, and throngs of ticks and mosquitoes and marauding deer flies.

This twelve-month journey into my backyard forest concluded on December 31, 2004, but I now realize this journey was really a beginning. The images on the pages of this book chronicle a time that could easily be forgotten by generations ahead. It is my desire to contribute to the preservation of the planet's environment starting with my backyard; thus, I view the photographs in this book as pathways for the preservation of Bear Brook and beyond. My hope is that this piece of earth and all it holds will be conserved and not destroyed or altered again by the hands of man. My desire is to protect these seventy acres, if only to provide a home for my neighbors—the exquisite wildlife. Perhaps my intent, and this book, will serve as an inspiration to others to preserve their own property. If we all take the time to appreciate our backyards and accept the responsibility to safeguard them, regardless of how large or small the area, the synergy we can create together has the power to rescue our natural world for the benefit of future generations.

I ask that you consider the peaceful grandeur that nature has shared and accompany me on a journey *By a Maine River*. In the words of Native American poet Linda Hogan, "There is a way that nature speaks, that land speaks. Most of the time we are simply not patient enough, quiet enough, to pay attention to the story."

Thomas Mark Szelog
Bear Brook Cabin
Whitefield, Maine

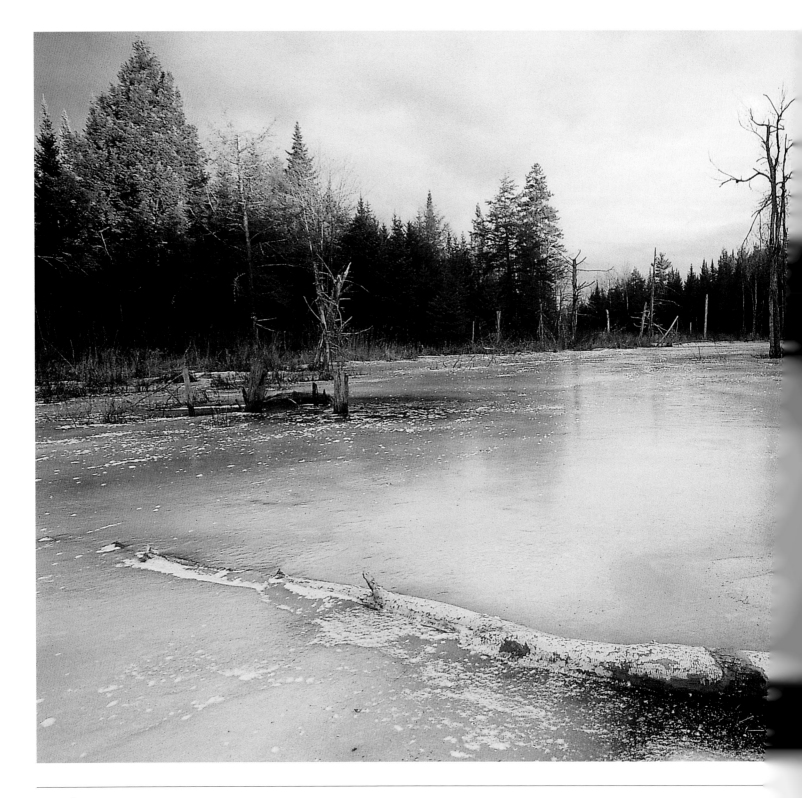

week one

East Branch of the Eastern River

The ice-covered river has entombed the final
tree chiseled by resident beavers before they
sought sanctuary from the approaching winter.
The low winter sunlight never penetrates the
deepest haunts of this meandering waterway.

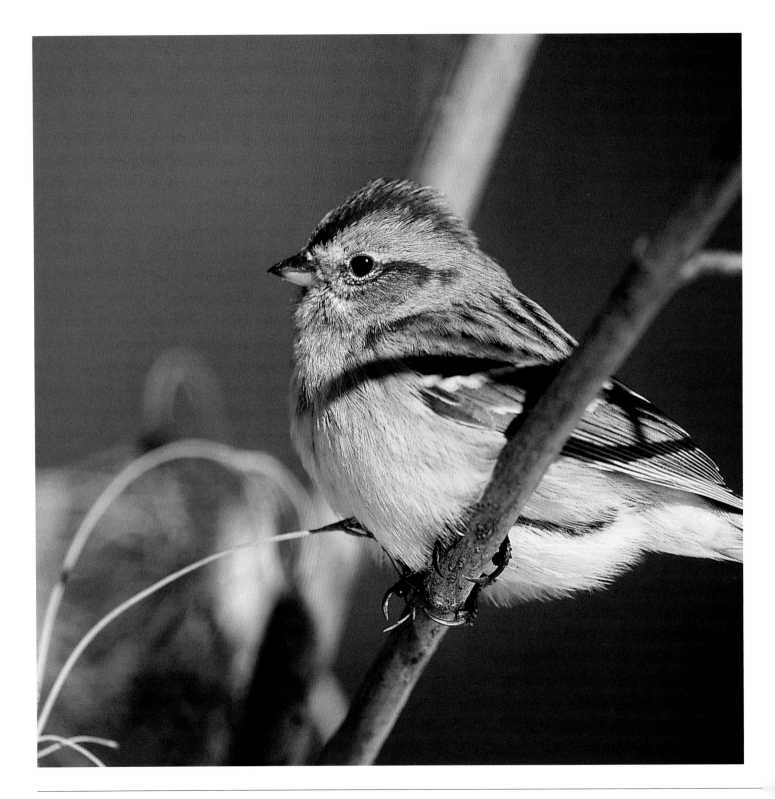

week two

Tree Sparrow

Deceptive sunlight masks a minus-
fifteen-degree air temperature.
Combating a wind-chill of thirty-five
below zero near Bear Pond, this hardy
tree sparrow strives to absorb warmth
from a weak daybreak sun.

Goshawk

The serenity of the forest is shattered by a menacing goshawk stalking its breakfast. This crow-sized predator is fearsomely efficient in its pursuit of squirrels, mice, and songbirds—in this case, a black-capped chickadee. Goshawks are rarely seen this close.

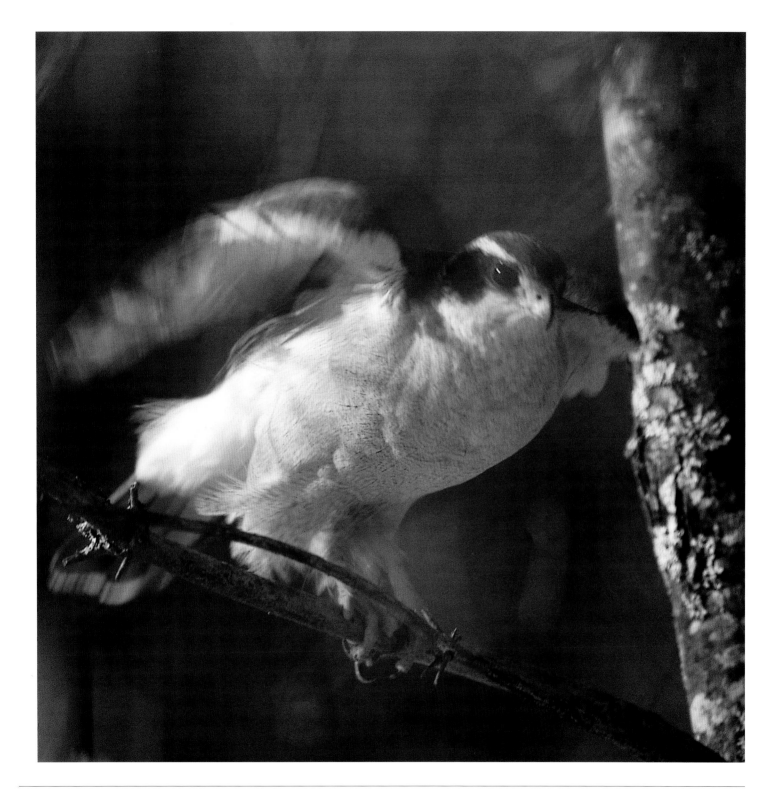

January 14

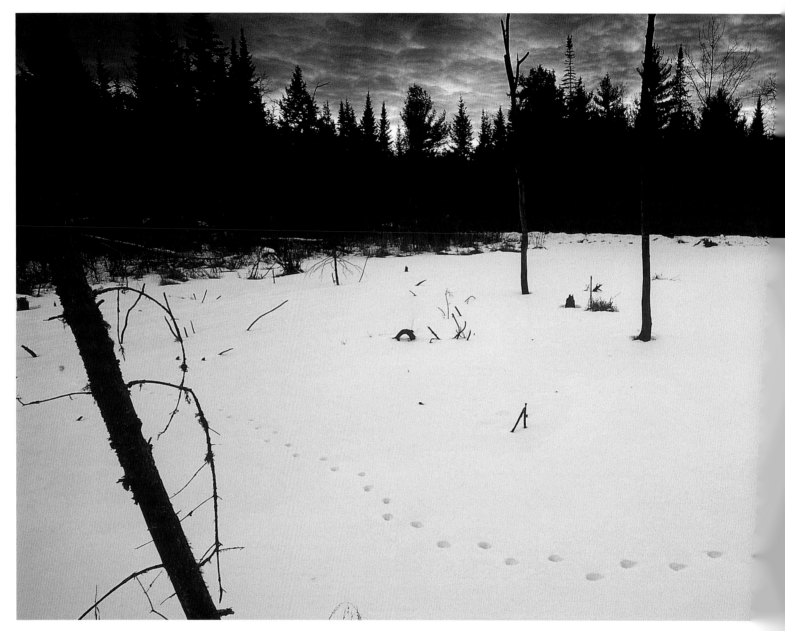

Bobcat Tracks on Bugaboo Pond

Slowly and purposefully, an elusive bobcat crossed
frozen Bugaboo Pond under cover of darkness,
leaving its footprints in the snow before returning
to the forest. This secretive denizen of deep woods
roams the river valley undetected but for its tracks.

week four

Mourning Doves

Shielded from the elements by the canopy
of an eastern white pine, these mourning
doves can nap, preen, and feed without the
hindrance of snow. The normally migratory
species may spend at least part of an average
winter in Maine if food remains available.

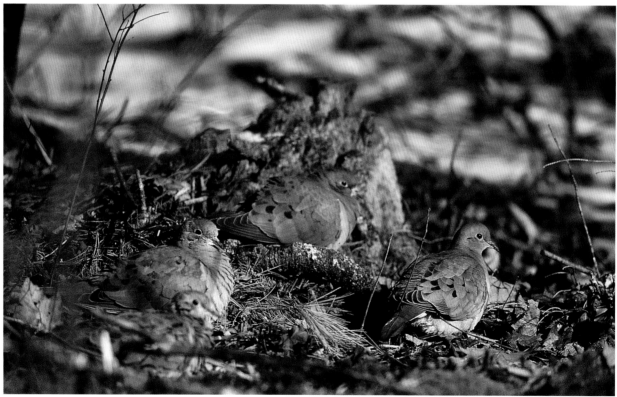

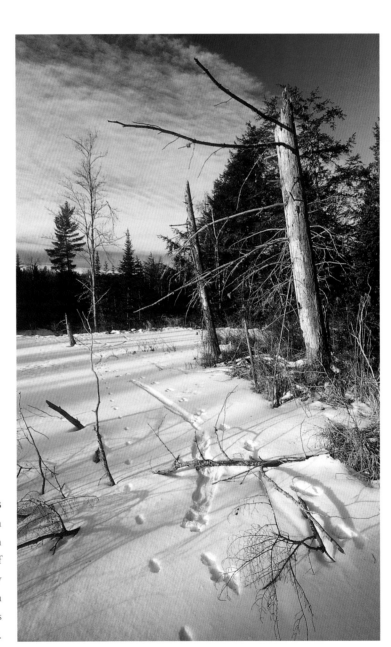

Coyote and Otter Tracks

Tracks in the snow on the frozen East Branch
of the Eastern River reveal the story of an
eastern coyote (left tracks) following a pair of
river otters (right tracks). Coyotes will follow
animals—both prey and other predators—in
their quest for food. Perhaps this coyote was
hoping to snatch a meal from the otters.

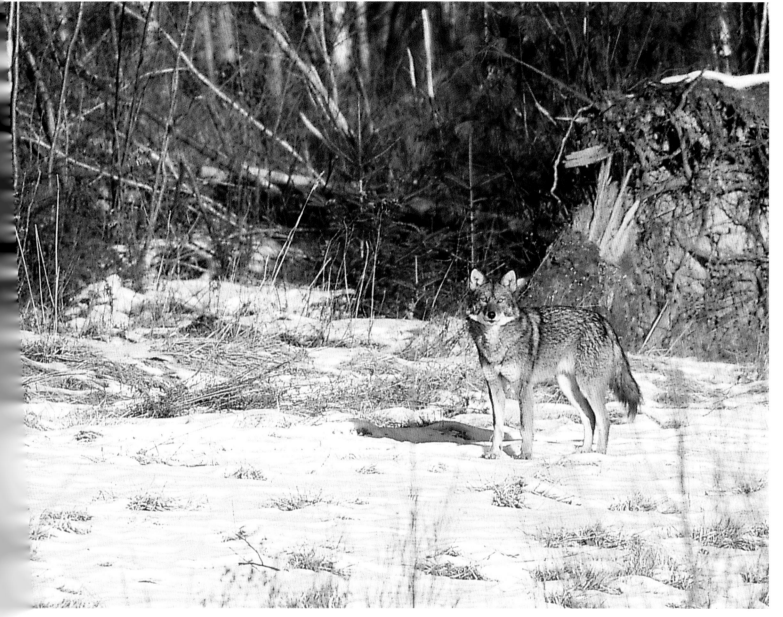

Eastern Coyote

The unmistakable howl of an eastern coyote announced its presence in a snow-covered field. Perhaps wanting to communicate with its packmates, the coyote instead attracted an unwanted intruder—the author—to its territory. With its morning hunt disrupted, the coyote retreated quickly into the dense woodland.

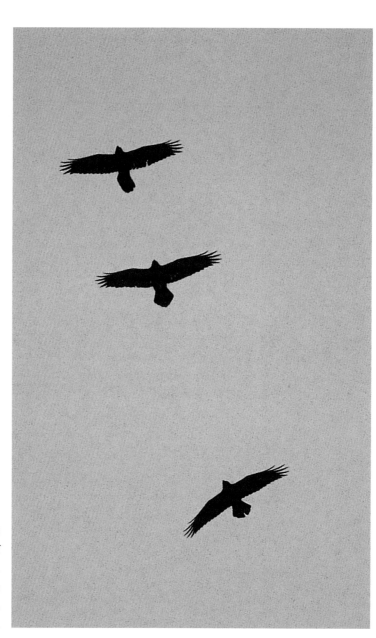

Northern Ravens
As nightfall approaches, a small flock of
ravens returns from a day of foraging.
Ravens are one of a number of species
that use communal roosts at night,
particularly during the winter months.

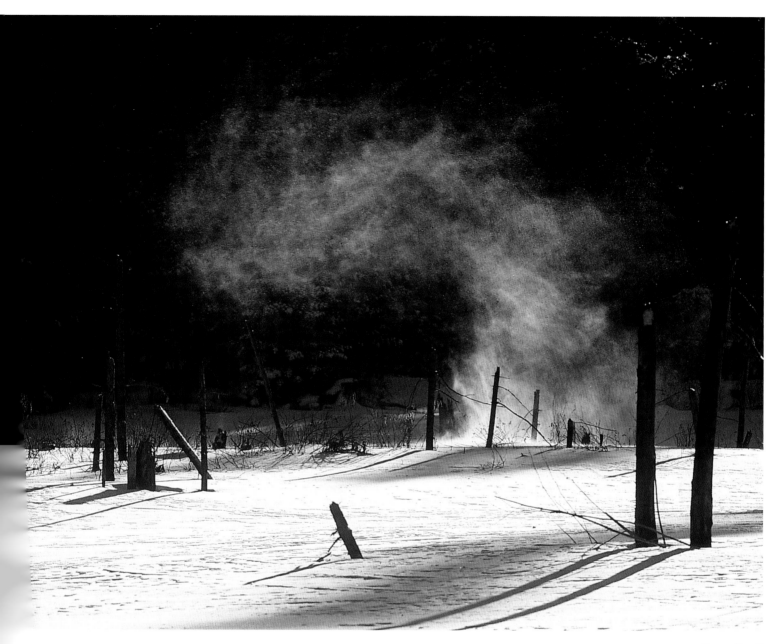

Snow Devil

Fine, powdery snow atop the
frozen river is twisted into a
funnel by the spinning energy
of a whirlwind, a winter version
of a dust devil or water spout.

Red Squirrel

Using its acute sense of smell, a red squirrel
searches for food in the snow. The red squirrel is
one of the more common small mammals in
northern timberland, exhibiting a preference for
evergreen forests of spruce, hemlock, and pine.

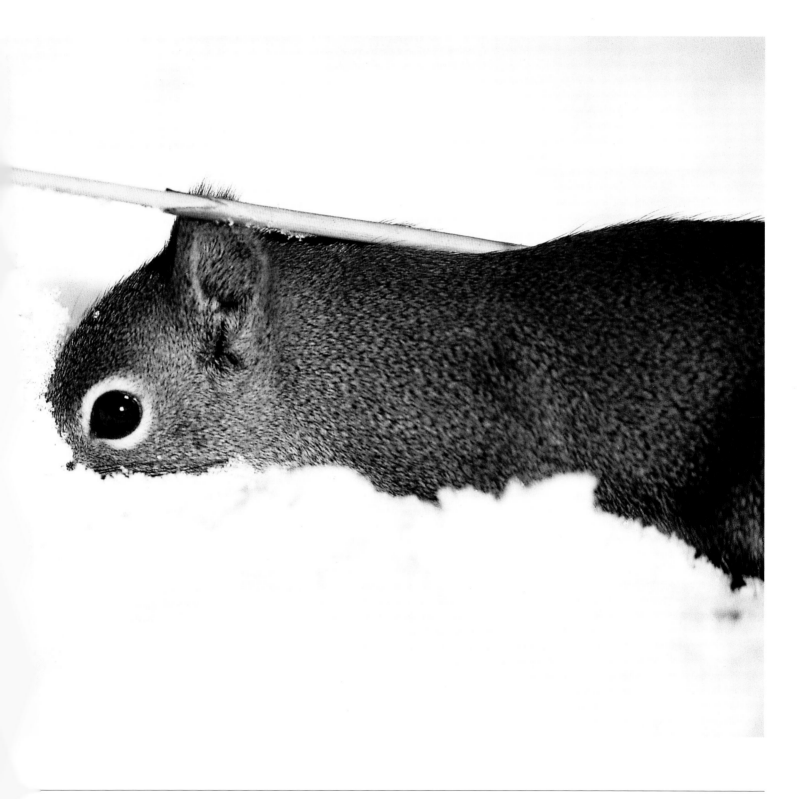

February 10

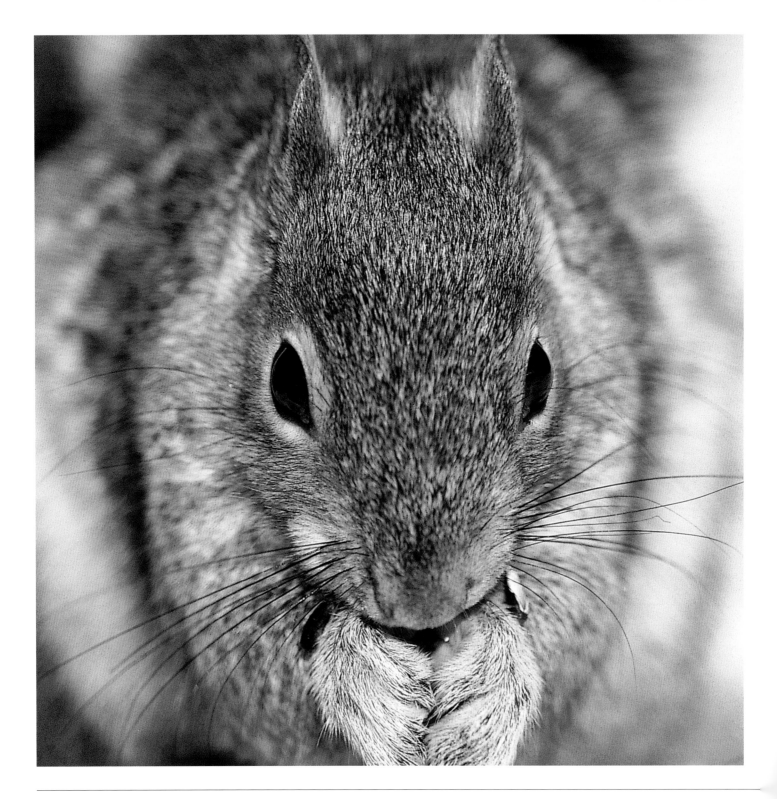

week eight

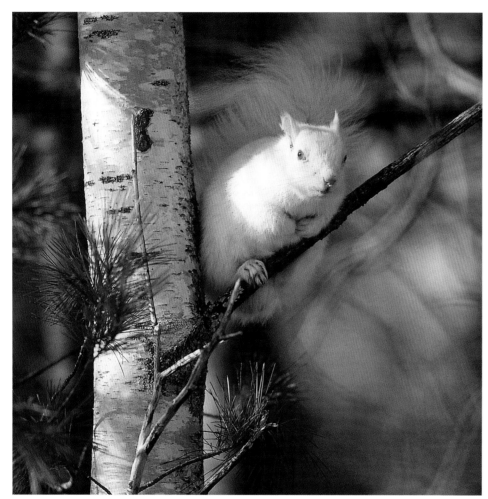

Albino Eastern Gray Squirrel
With pink eyes and fur color like that of a snowshoe hare in winter, a rare true albino gray squirrel emerges ghostlike from the dark forest. Through the snowy winter it enjoys a brief advantage in cammoflage, but will be extremely vulnerable to predators once the snowcover melts.

Eastern Gray Squirrel
Eastern gray squirrels are abundant in their preferred habitat of hardwood and mixed hardwood/softwood forests. Unlike their cousins found in city parks, Maine's wild squirrels are nervous and wily creatures.

week nine

Drooping Evergreens
Branches sag from the weight
of an overnight snowfall until
the warming sun loosens the
snow, allowing it to fall
tranquilly to the ground.

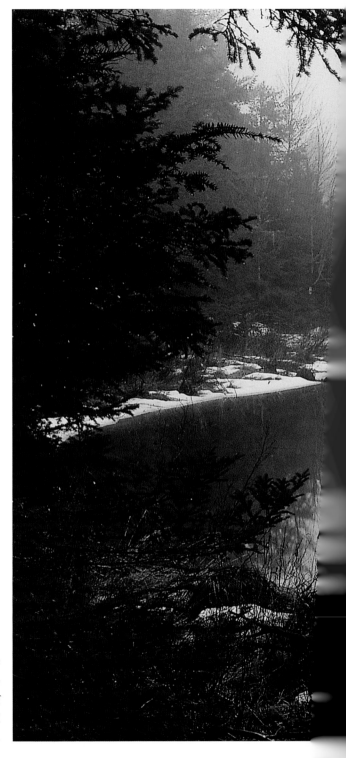

Otter Valley

Contrasting snow cover harmoniously
borders the meandering, dark waters of
the East Branch. The valley is aptly named
for a resident family of river otters.

week ten

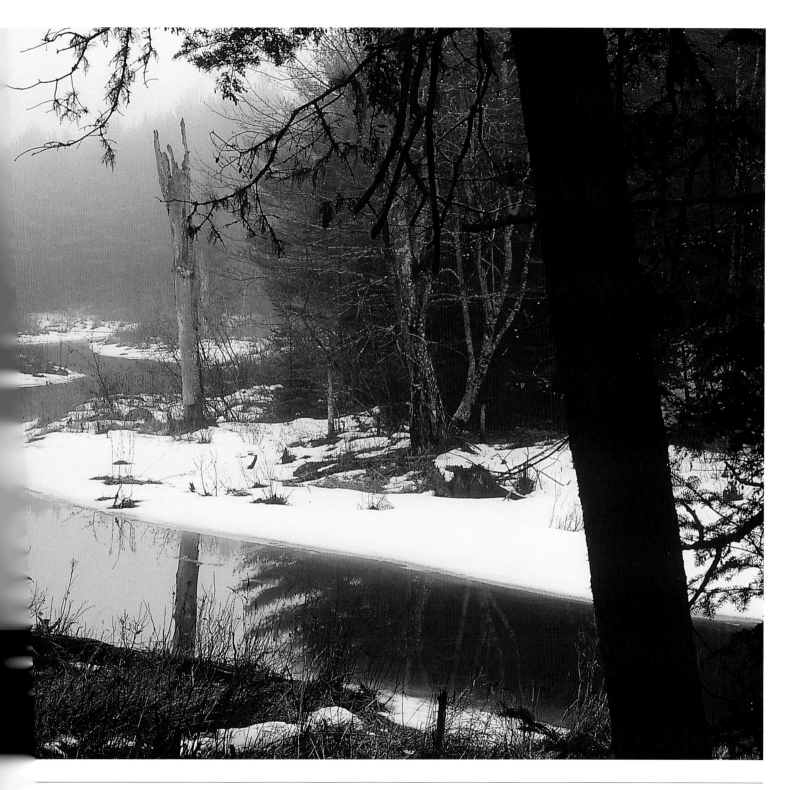

March 6

week eleven

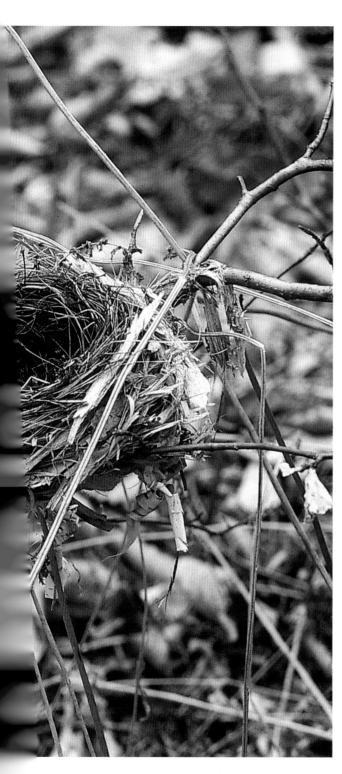

Bird's Nest

When spring arrives, nests like this
one will be filled with young birds
clamoring for food. Although there
are exceptions, nests are seldom used
from year to year; only the sturdiest
of them will survive a harsh winter.

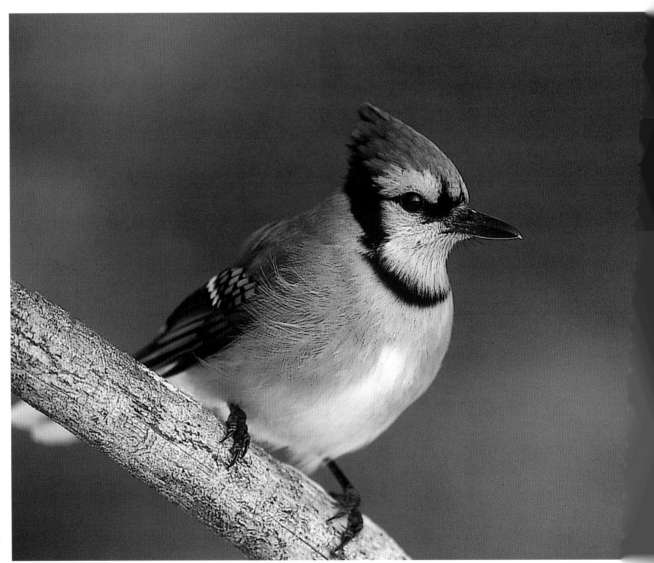

Blue Jay
Busy and vocal, blue jays
are a welcome presence
in the winter forest.

week twelve

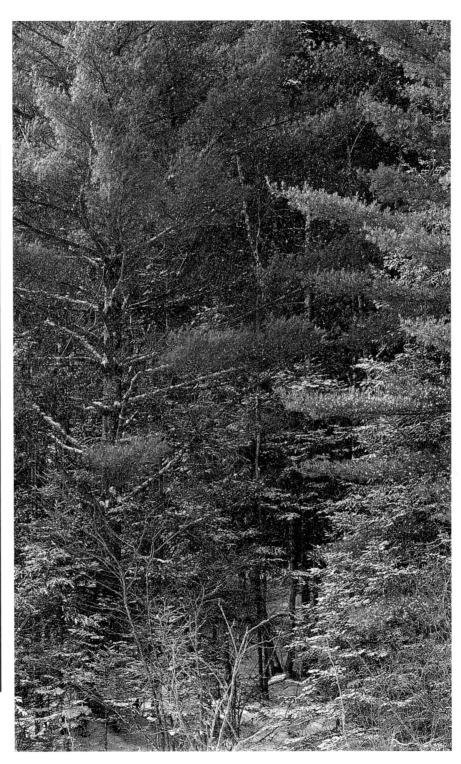

Towering Forest Canopy

A dusting of snow adorns the hardwoods and conifers that share this transitional forest.

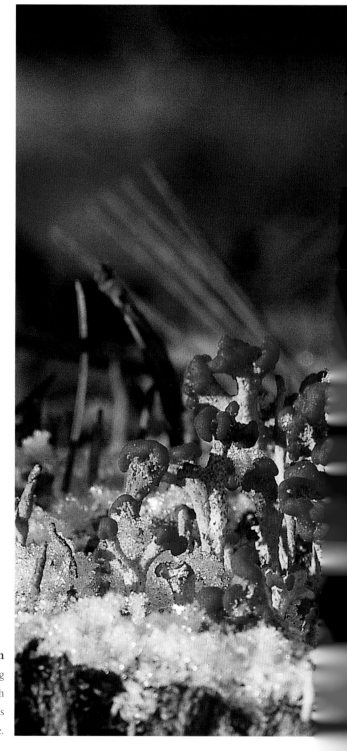

British Soldier Lichen
Winter's snow gradually recedes, uncovering intimate details of the forest floor. This British soldier lichen, growing on a decaying tree, is no taller than the legs of a deer mouse.

week thirteen

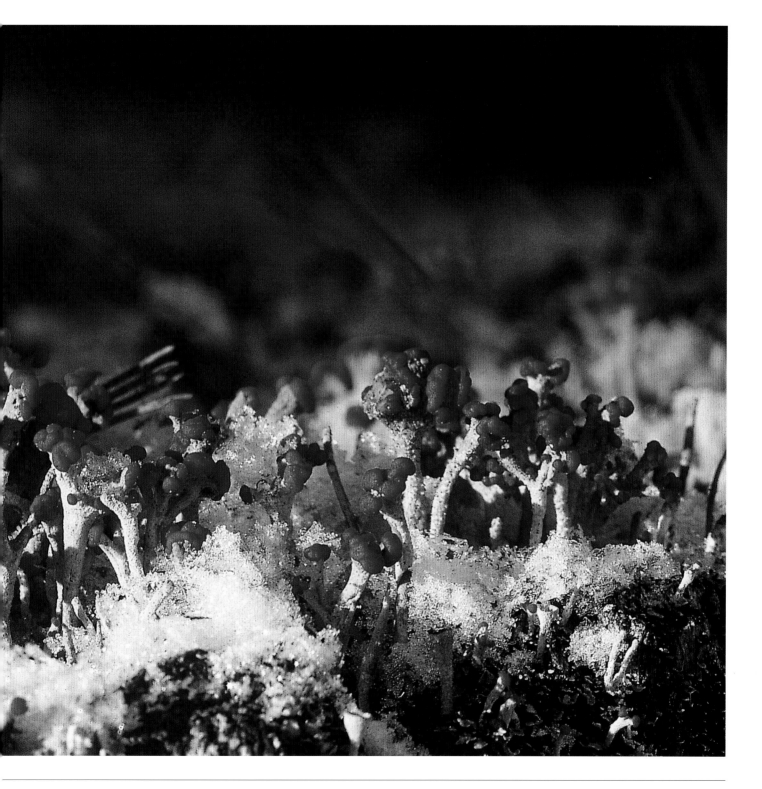

March 24

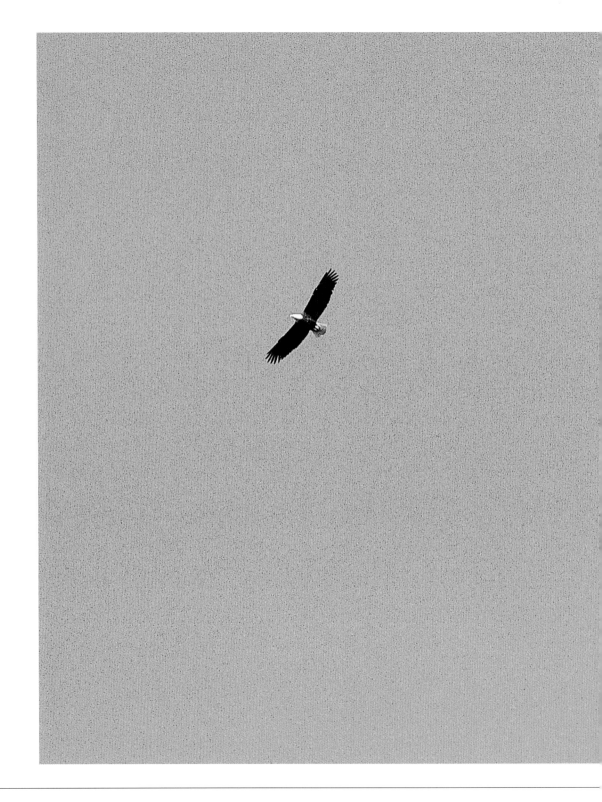

week fourteen

Bald Eagle

Soaring ever higher on a
rising thermal of warm air,
this adult bald eagle ascended
beyond sight within minutes.

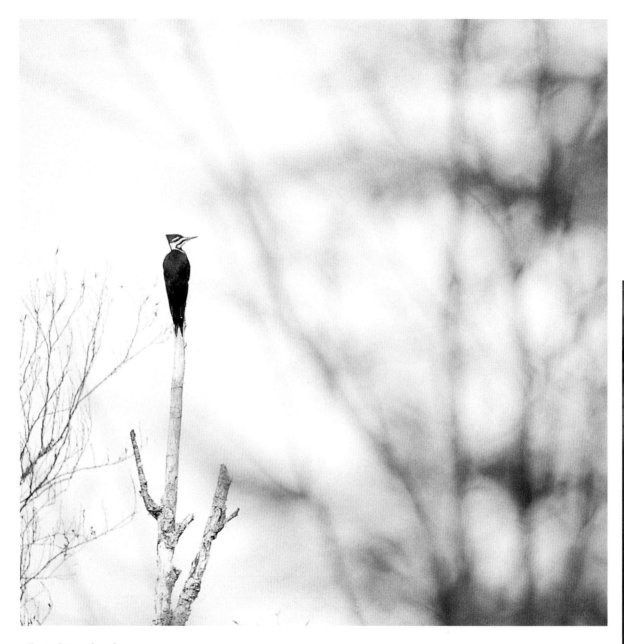

Pileated Woodpecker

A tall dead tree trunk offers a pileated woodpecker a
panoramic view of the surrounding forest. This crow-size
bird is North America's largest living woodpecker.
Although the ivory-billed and imperial woodpeckers are
bigger than the pileated, both species are probably extinct.

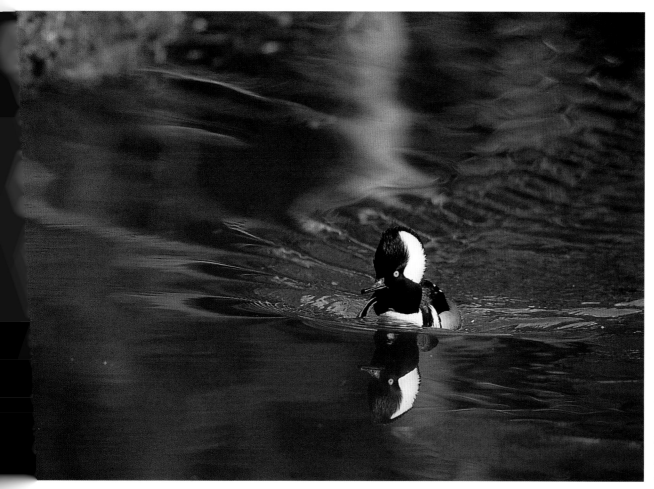

Hooded Merganser

Patches of ice-free water appear in April, luring the first migrant ducks of spring. This elegantly marked male hooded merganser is using his barely audible cry to entice a mate. Similar to wood ducks, hooded mergansers are cavity nesters.

Vernal Pool
Beneath the expanse of forest canopy, a
lustrous bed of leaves lines the bottom of a
seasonal pool of runoff and rainwater that will
soon resound with the chorus of breeding
spring peepers, Maine's smallest frogs.

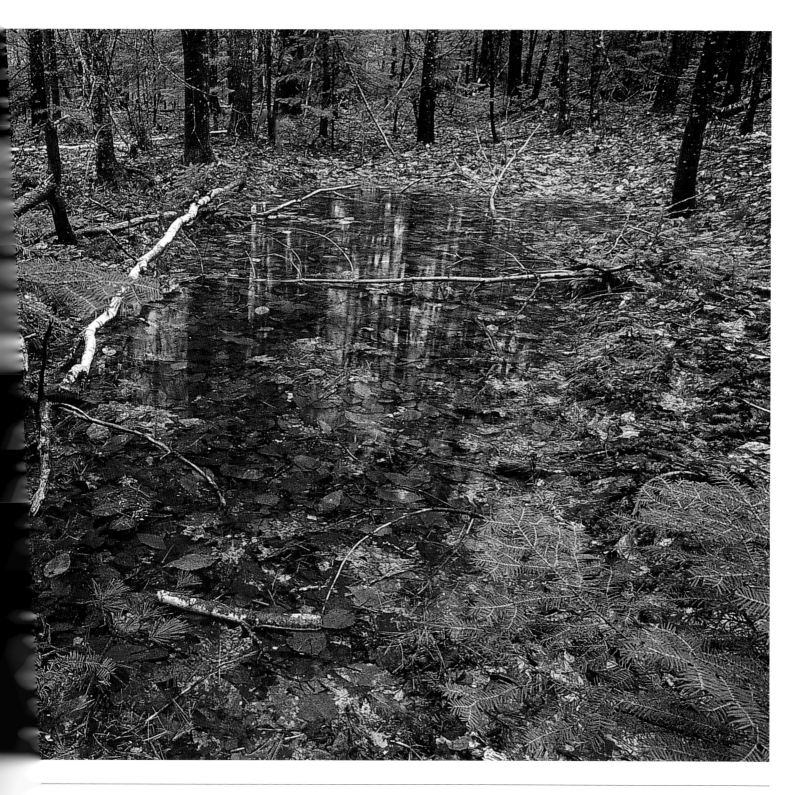

April 14

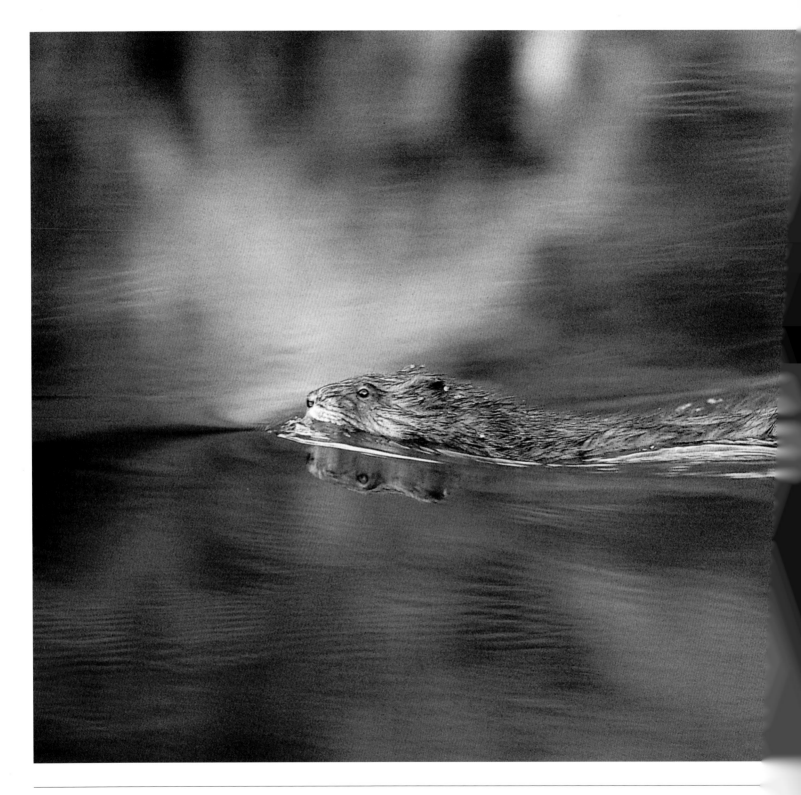

week seventeen

Swimming Muskrat
The ripple of a muskrat gliding through its reflection cracks the mirrored surface of the river. The large rodent's name comes from two musky-smelling scent glands near the base of its tail.

Wood Frog Eggs

Gelatinous egg masses float near the surface
of Bear Pond. The frogs favor the pond as an
egg nursery for a number of reasons, one
of which is of the lack of predatory fish.

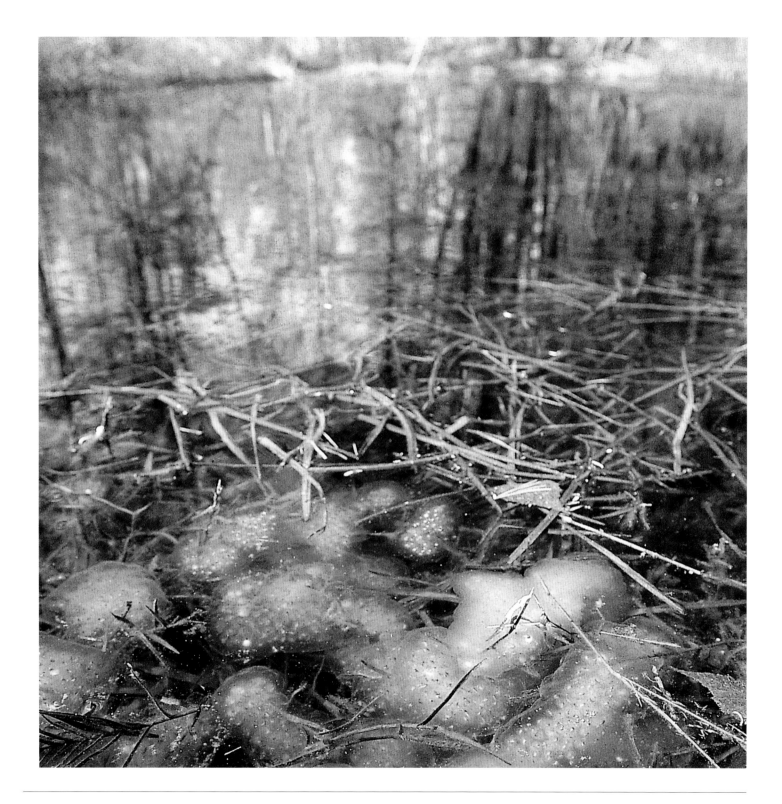

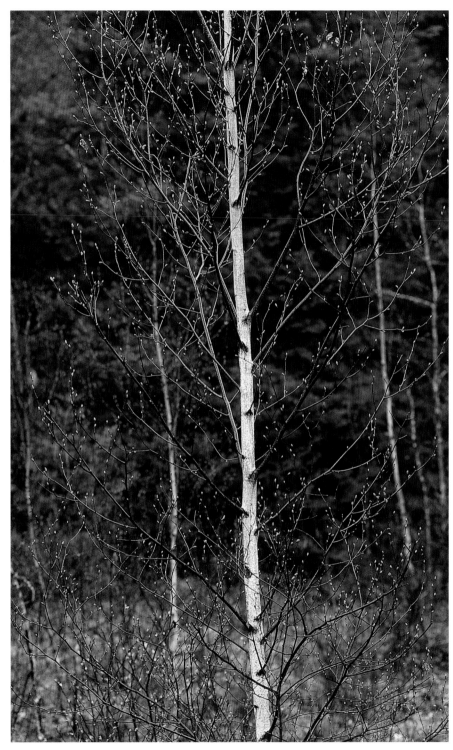

Paper Birch

Warm weather and rejuvenating spring rains trigger the emergence of the season's first tree buds. The saturated earth is soft, muddy, and fertile.

Beaver

Although beavers are primarily bark eaters, they consume a variety of other plants. Here, utilizing its dexterous front paws, a beaver grasps succulent vegetation flourishing along the woody shoreline in Otter Valley.

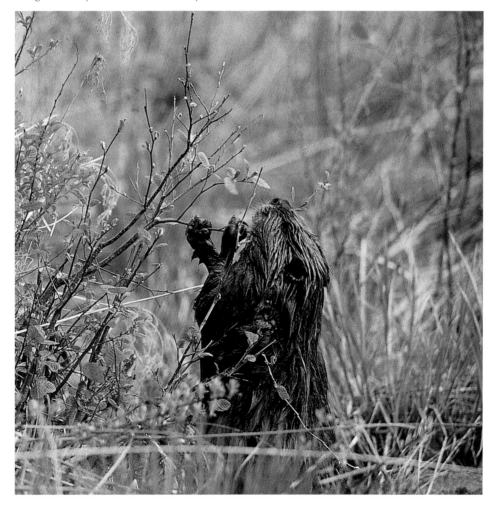

week twenty

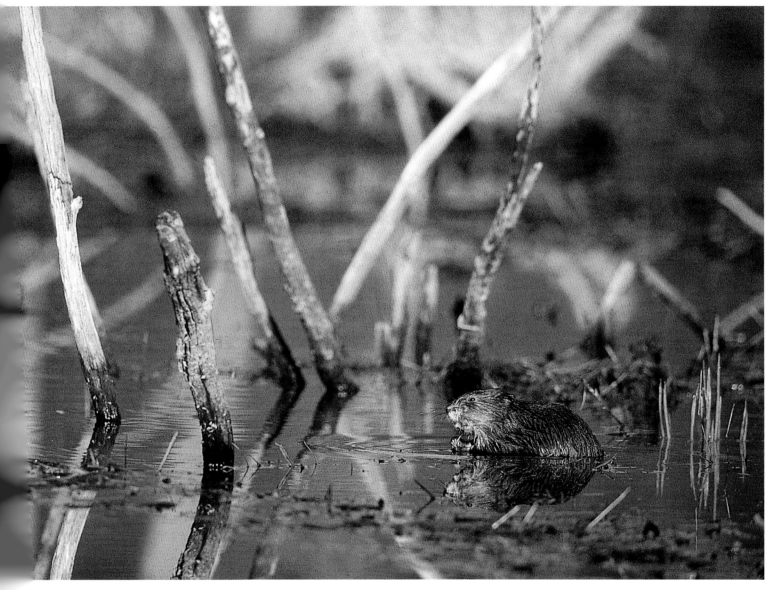

Feeding Muskrat

This muskrat, a member of a family that
dwells in an abandoned beaver lodge on
Bugaboo Creek, voraciously devours some
of the first green shoots of the year after a
long winter of less palatable fare.

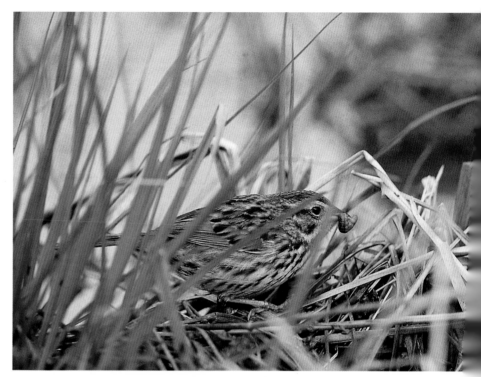

Breakfast
Near the water's edge, a hidden Lincoln's sparrow snatches a caterpillar. This shy, unobtrusive bird is often mistaken for its common and better-known relative, the song sparrow.

Bath Time
Following breakfast, the sparrow bathes by splashing and "flipping" water with rapid twisting of its head.

Common Yellowthroat
A female common yellowthroat, a small warbler, pauses while traveling with its mate through a marshy thicket.

week twenty-one

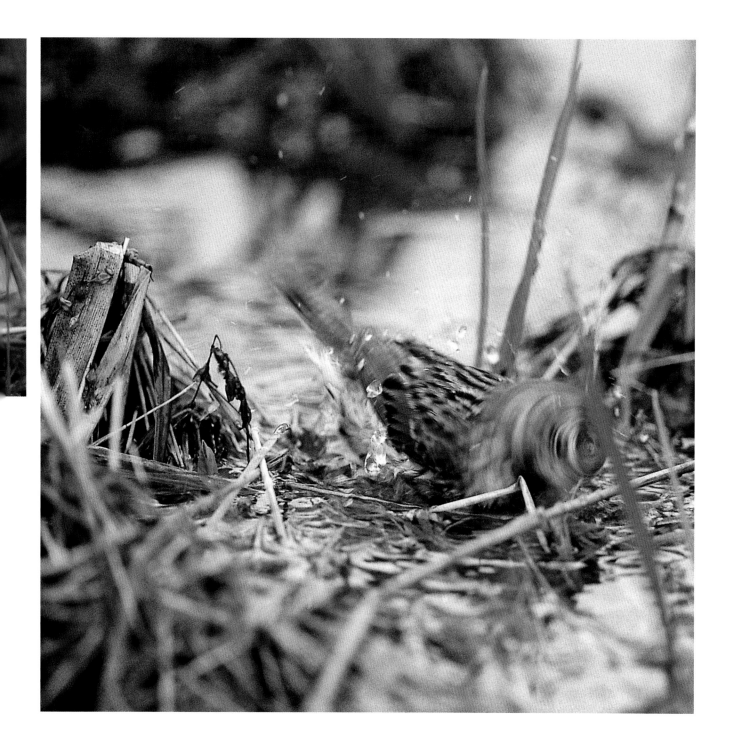

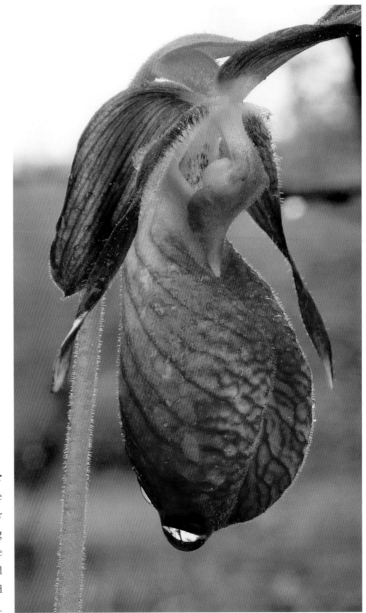

A Lady's Slipper

Raindrops flow gracefully down the elegant flower of a pink lady's slipper orchid. These rare plants are among the most beautiful wildflowers. The pink lady's slipper is the official wildflower of New Hampshire and Canada's Prince Edward Island.

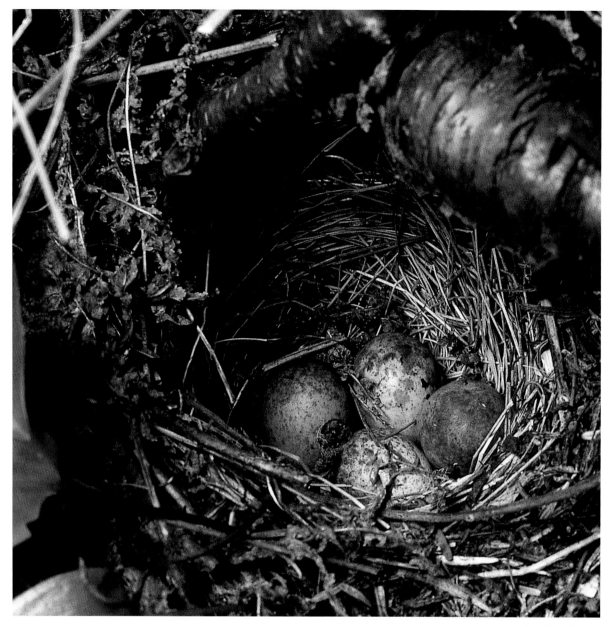

Hidden Secret

Concealed upon the forest floor where
light barely penetrates, the tiny, egg-
filled nest of a white-throated sparrow
measures less than four inches wide.

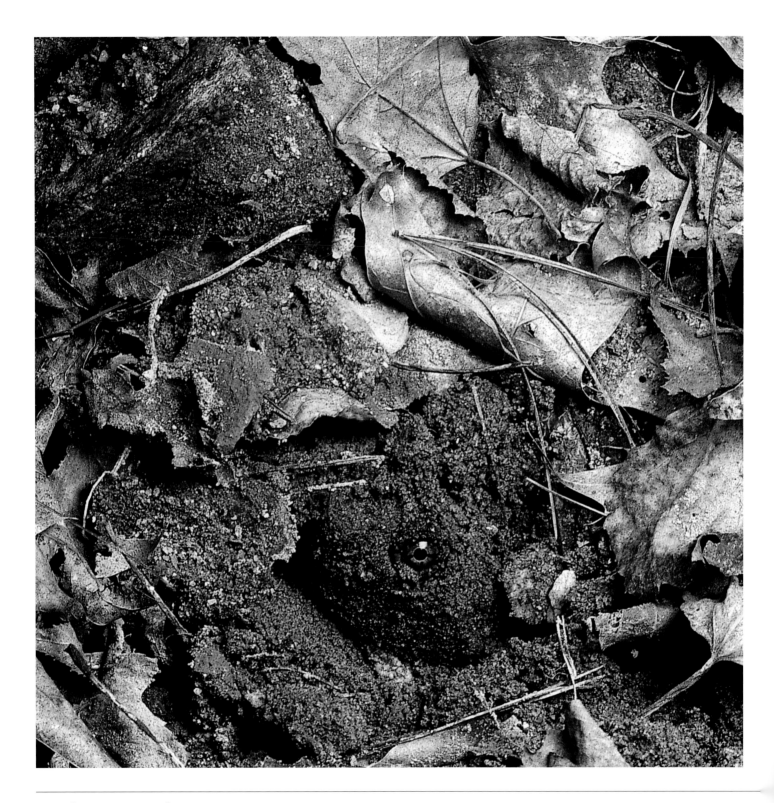

week twenty-four

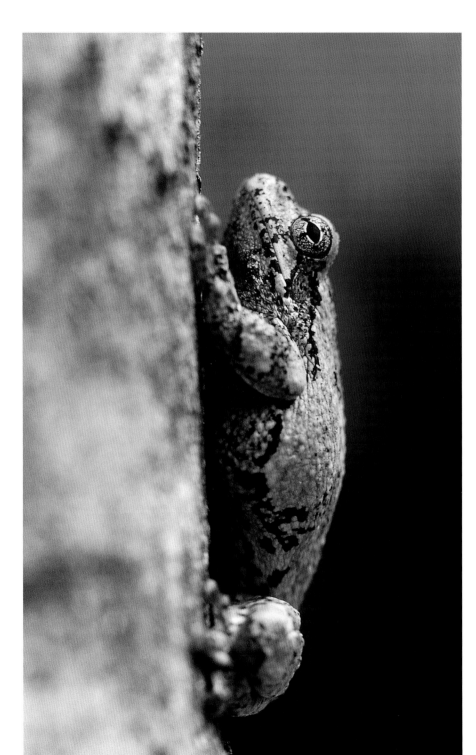

Eye of the Turtle

Buried in wet sand and leaf litter on the forest floor, a fifteen-inch-long snapping turtle remains cool in ninety-degree midday heat. Only a portion of its distinctively large head remains exposed.

Gray Tree Frog

Using its large, sticky toe pads to rest vertically on a tree trunk, this now-quiet gray tree frog will attempt to attract a mate by "singing" vibrantly during the approaching evening. The call of this species is one of the loudest of North American frogs.

Dragonfly

Dragonflies feast upon mosquitoes, which are plentiful throughout the forest and wetlands. Along with consuming vast numbers of insects, dragonflies are a visible indicator of wetland diversity and health.

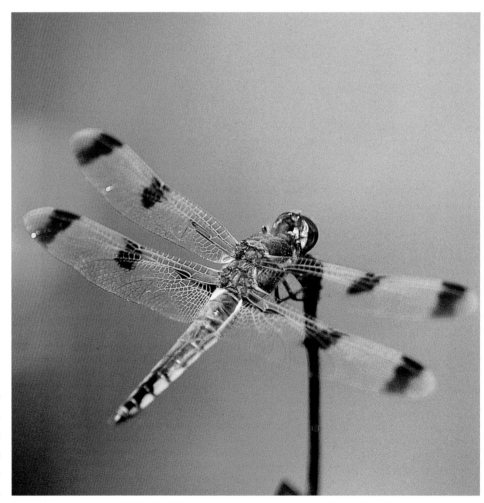

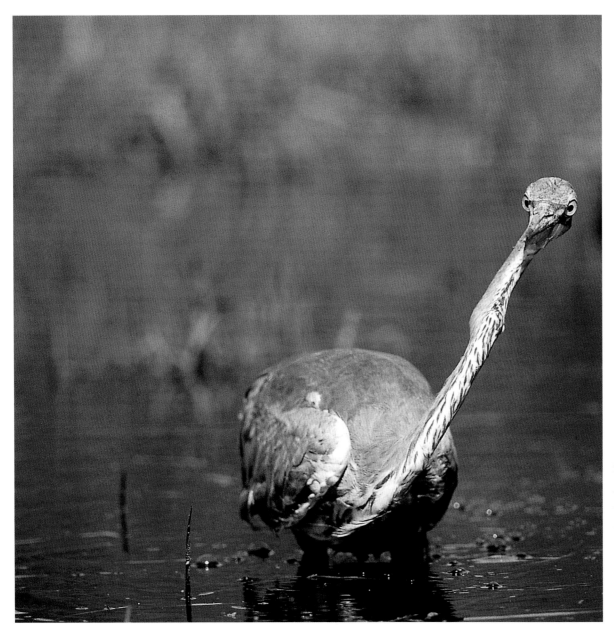

Focused

A great blue heron concentrates on a small fish swimming in the shallows of Bugaboo Creek. Seconds later, the heron effortlessly caught, then swallowed, the fish.

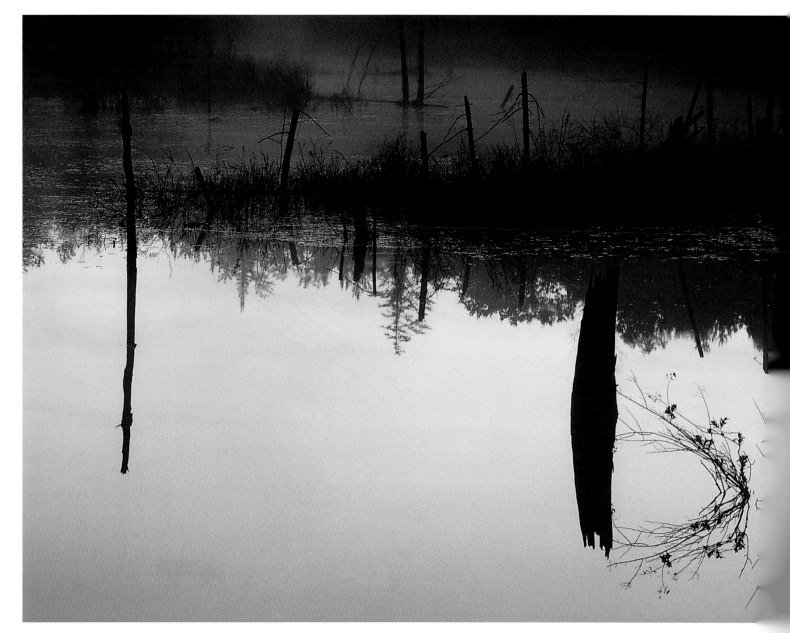

Dawn on the River

During the summer months,
fog drifts faster than the current
of the nearly still, reflective
waters of the East Branch.

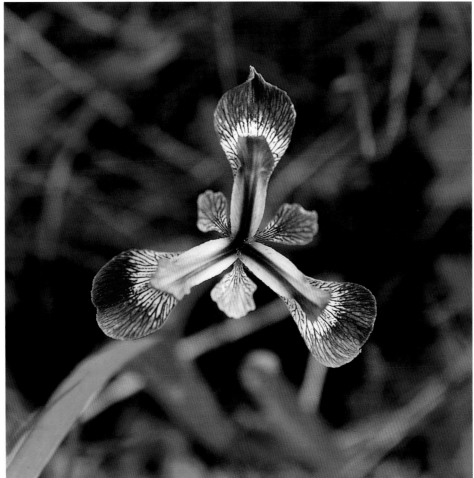

Blue Flag Iris

Often found growing in or near wetlands, blue flag irises are northcountry natives that lend a touch of resplendent color to their habitat.

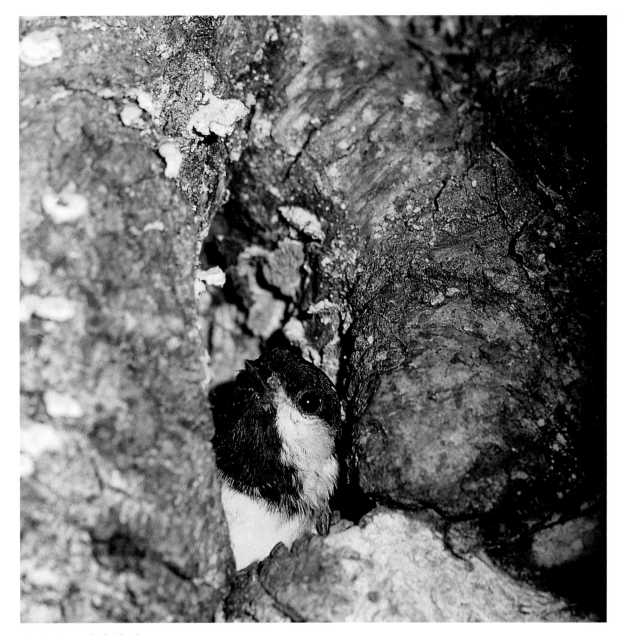

Black-Capped Chickadee

From a cavity in a decaying tree trunk, an adult
black-capped chickadee surveys its surroundings
before departing its nest. Both the male and female
will care for their recently hatched young.

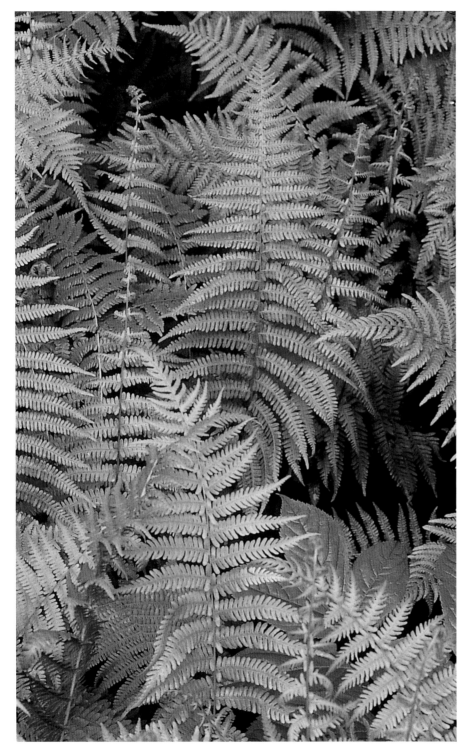

Ferns

Lush midsummer vegetation
provides refuge for forest
denizens such as white-tailed
deer, red fox, and turkeys.

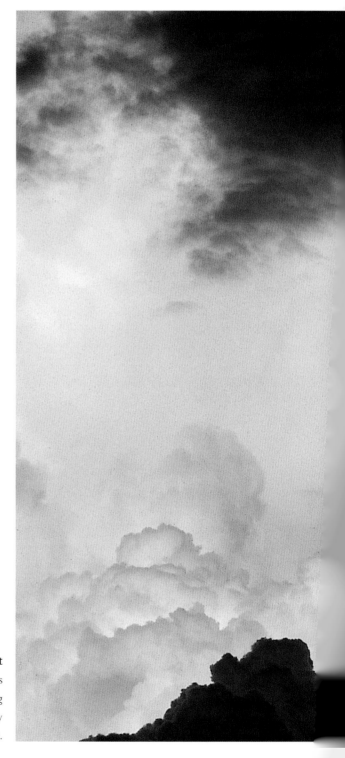

Storm Front
Ominous thunderheads
grow like a living
organism in a quickly
developing tempest.

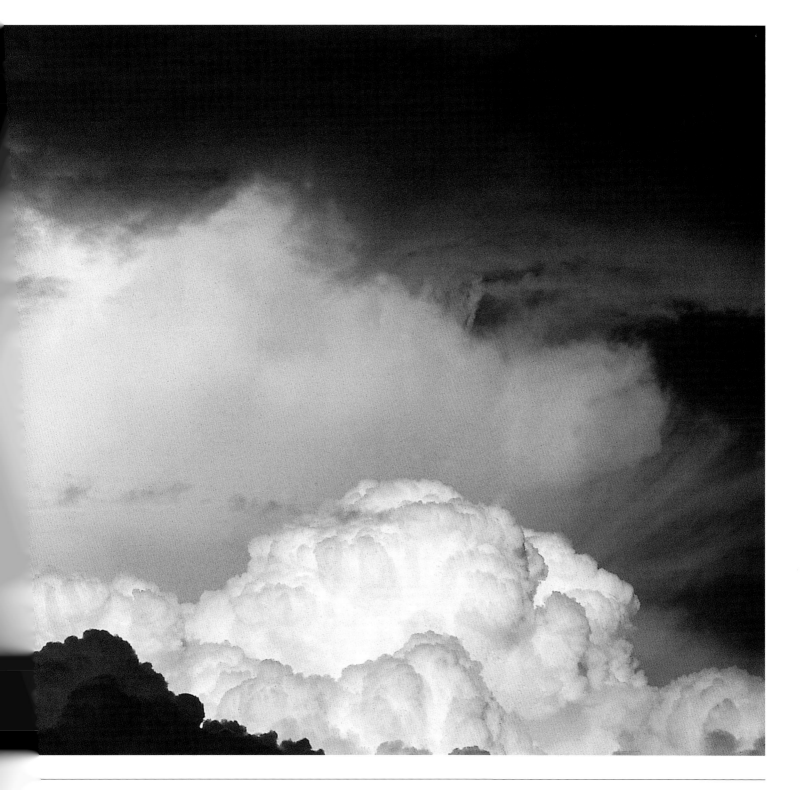

July 17

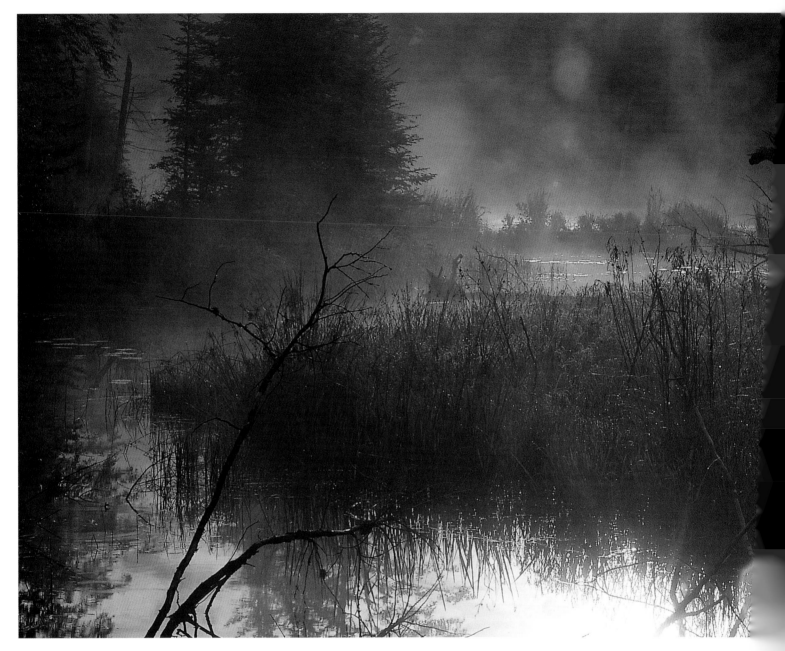

Cold Fog

A low, rising sun warms the
forty-eight-degree air, creating a
dark layer of nearly impenetrable
fog over the quiet river.

week thirty

Damselfly

A profuse growth of reeds on the edge
of Bugaboo Pond is home to this
metallic blue damselfly. Relatives of the
dragonflies, these slender, delicate
insects are rarely found away from water.

July 21 & 25

Common Yellowthroat

A female common
yellowthroat pauses while
feeding on insects in a
marshy thicket.

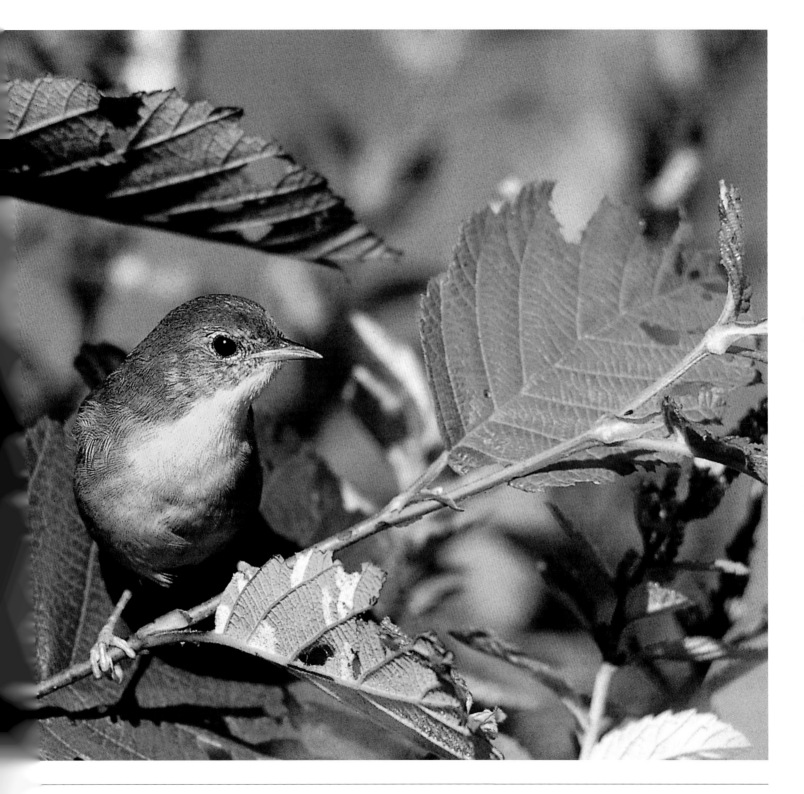

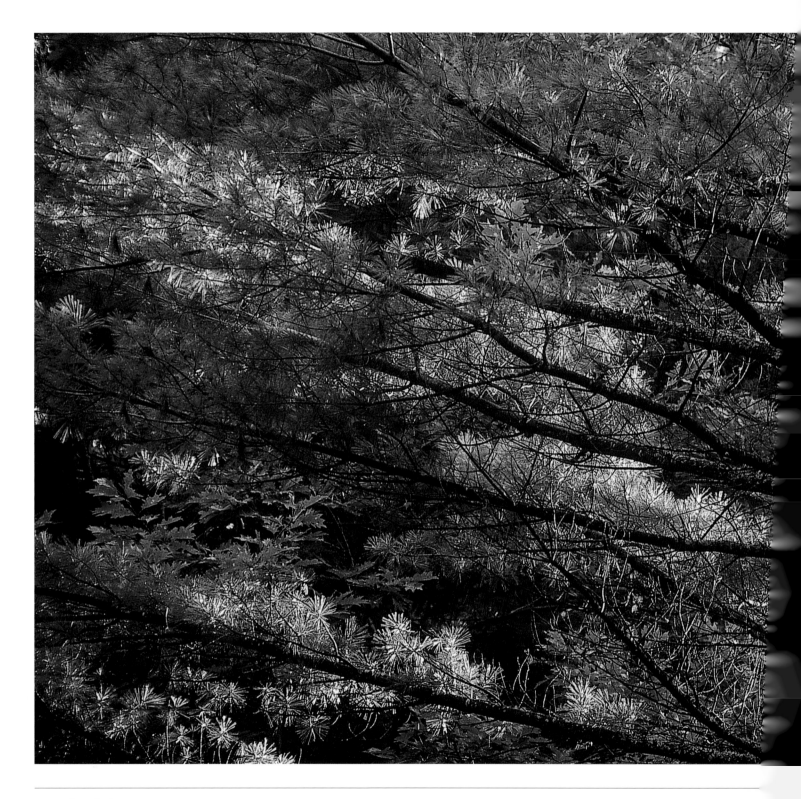

week thirty-two

Evergreen Light

Waning beams of sunlight
cast a soft glow through the
branches of one of the more
common species of trees in
Maine, the stately white pine.

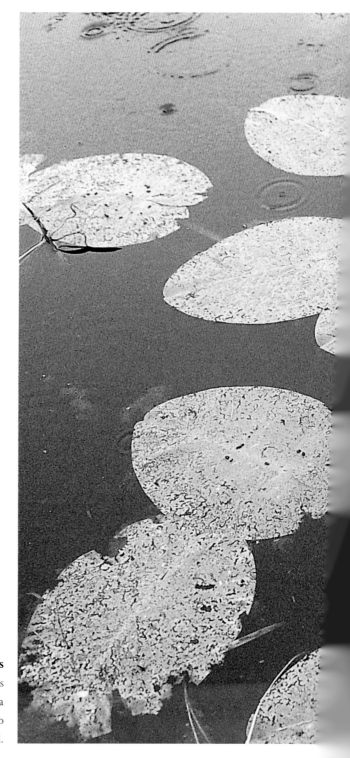

Remnants
Descending as a harmless
light rain, the remains of a
hurricane barely disturb
the lily pads on Bear Pond.

week thirty-three

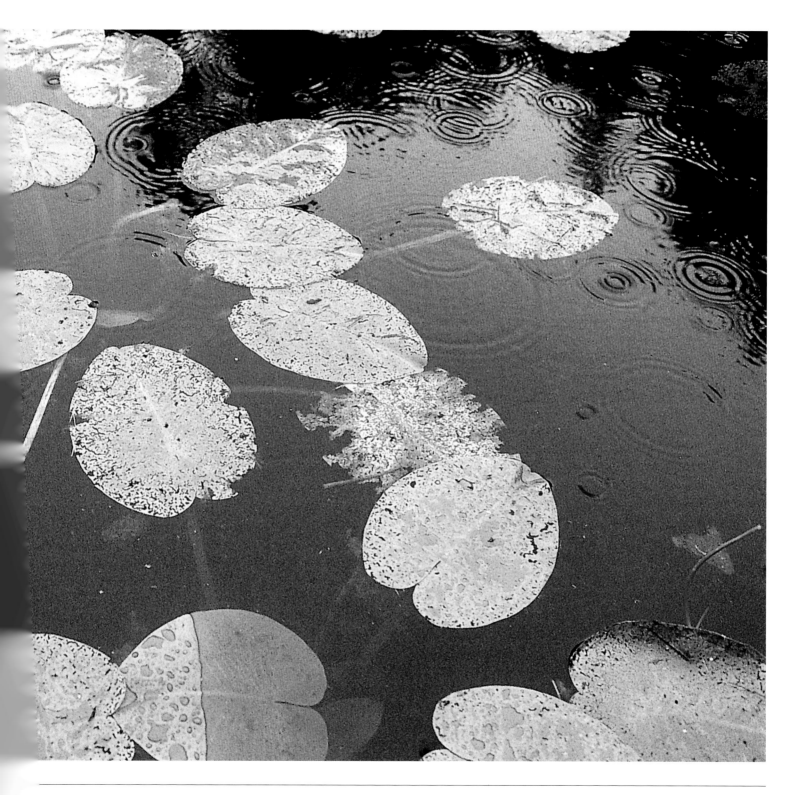

August 15

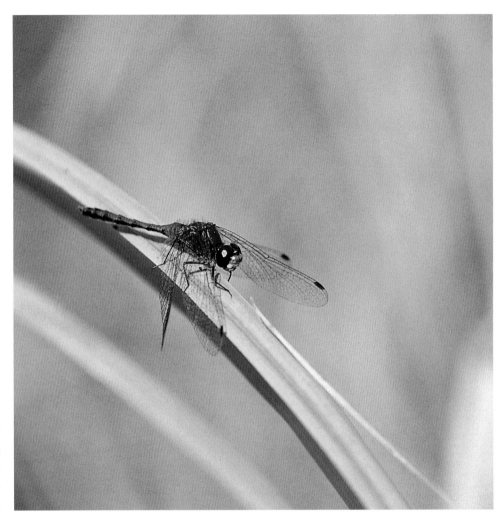

Dragonfly

Dragonflies, like this relatively common species, perch with their wings held out to the sides, while damselflies usually hold them together over their backs.

Morning Dew

Contrasting vibrantly against the dark forest, a spider's intricate web is brilliantly illuminated by the morning sun.

week thirty-four

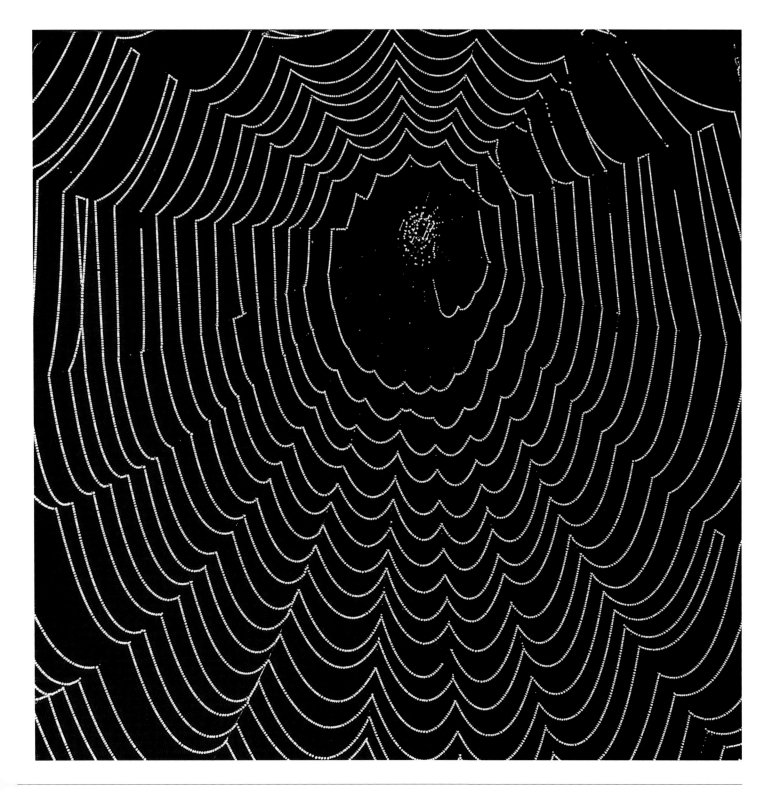

August 17 & 22

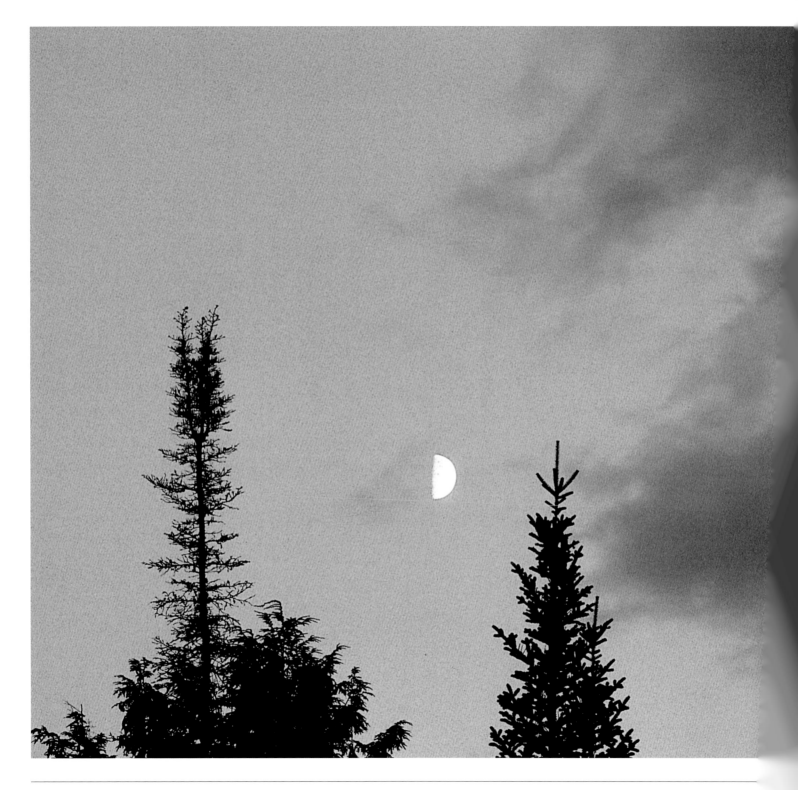

week thirty-five

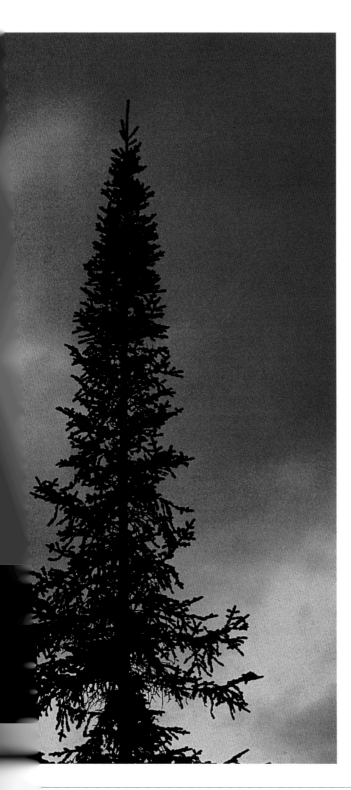

Moonset
Advancing clouds, signifying a
change in weather, will soon
cover a first-quarter moon.

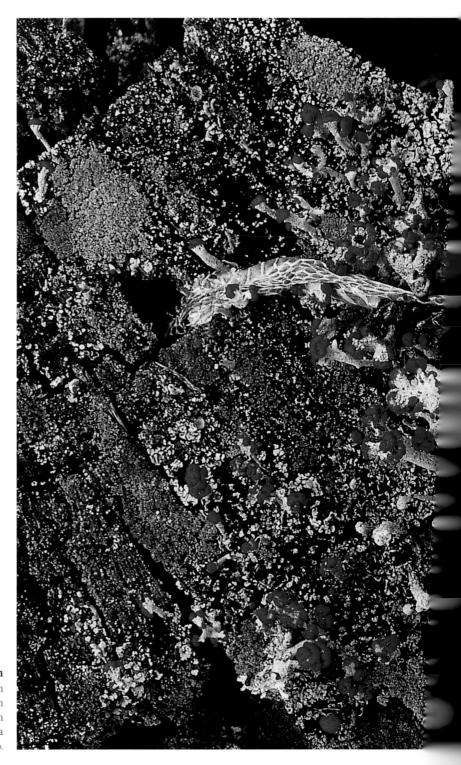

Snake skin
A green snake shed its skin by rubbing against the rough edges of red-topped British soldier lichen growing atop a decaying tree stump.

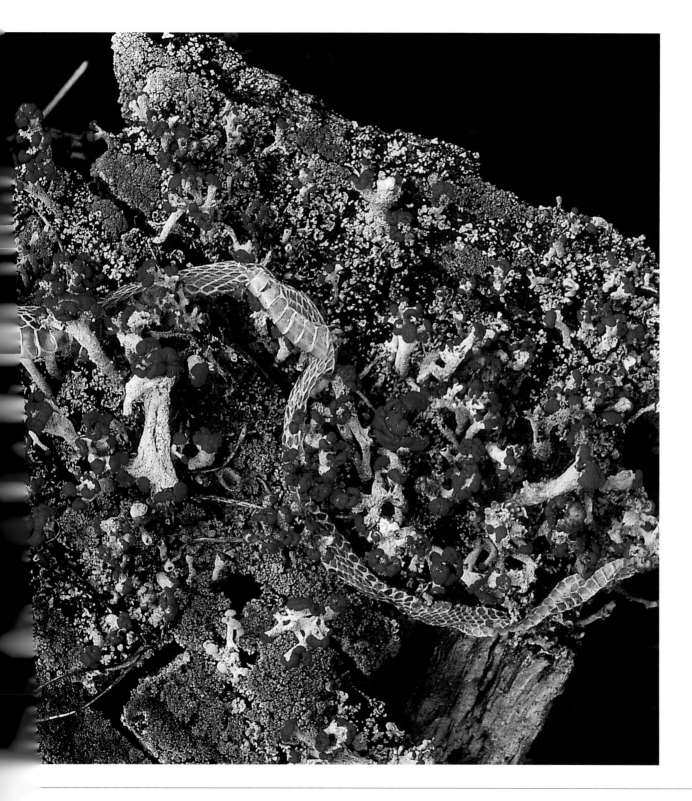

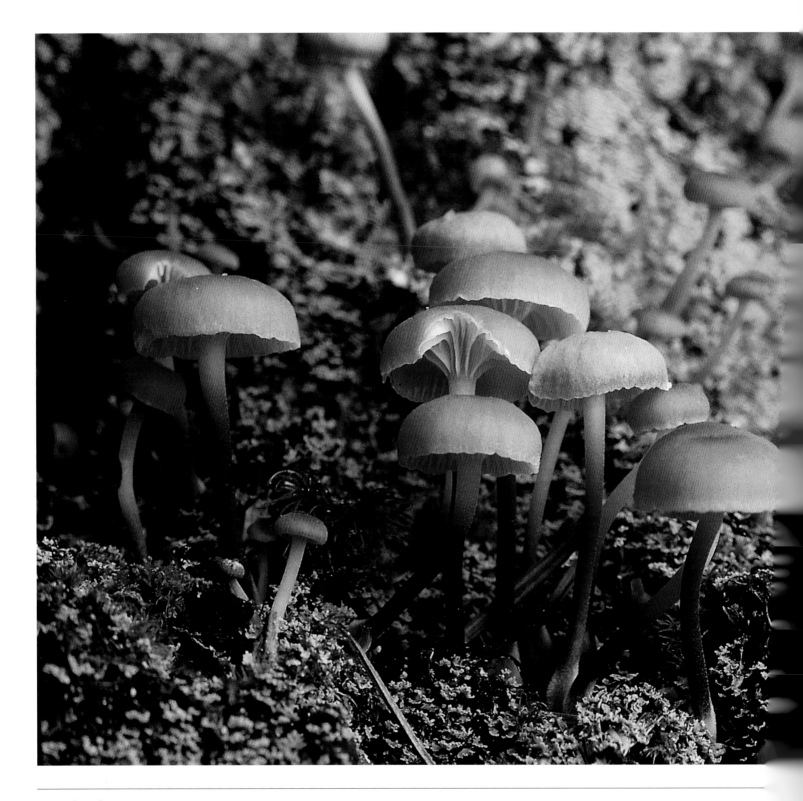

week thirty-seven

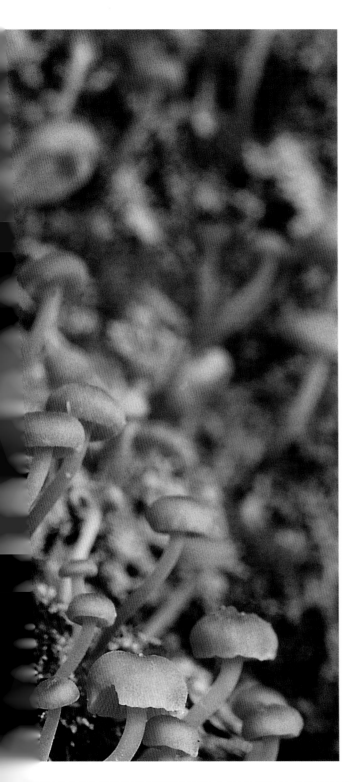

Mushroom Forest

Damp weather of late summer is conducive to the sudden growth of mushrooms on the forest floor. "Groves" of tiny mushrooms, such as these half-inch specimens, may emerge almost overnight under favorable conditions.

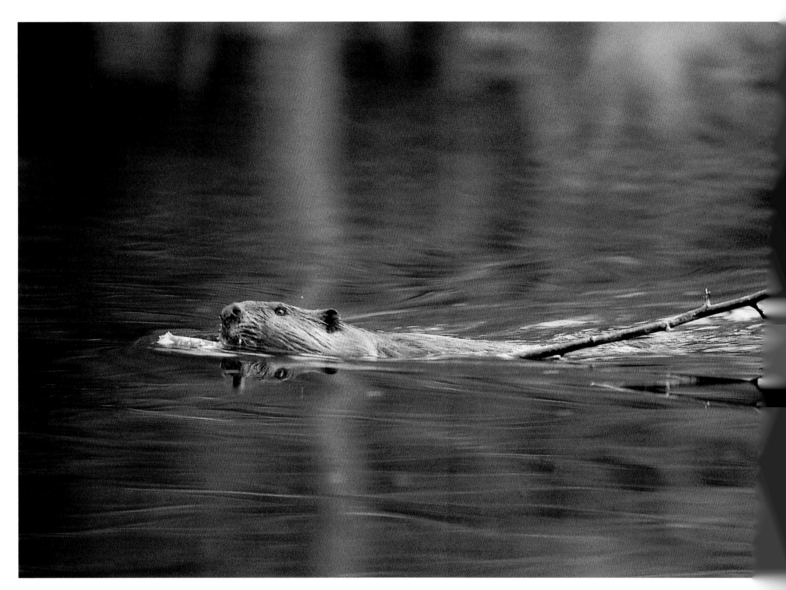

Busy as a Beaver

A beaver prepares for winter by hoarding hardwood branches near its lodge, allowing easy, under-the-ice access to its food source. Depending on the size of a beaver colony, these food caches can be quite large.

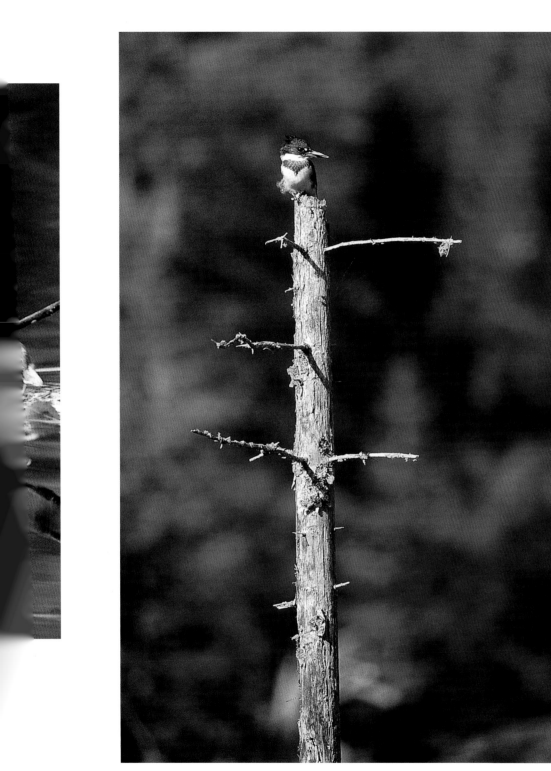

Kingfisher

Perched high above the East Branch, this belted kingfisher will dive beak-first into the water to nab a fish for breakfast.

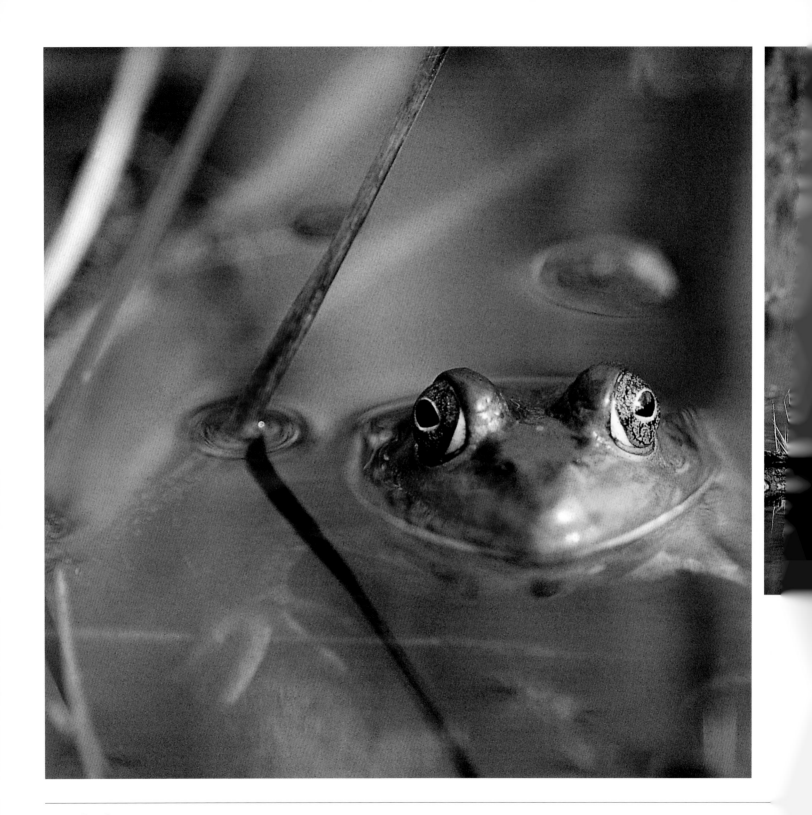

week thirty-nine

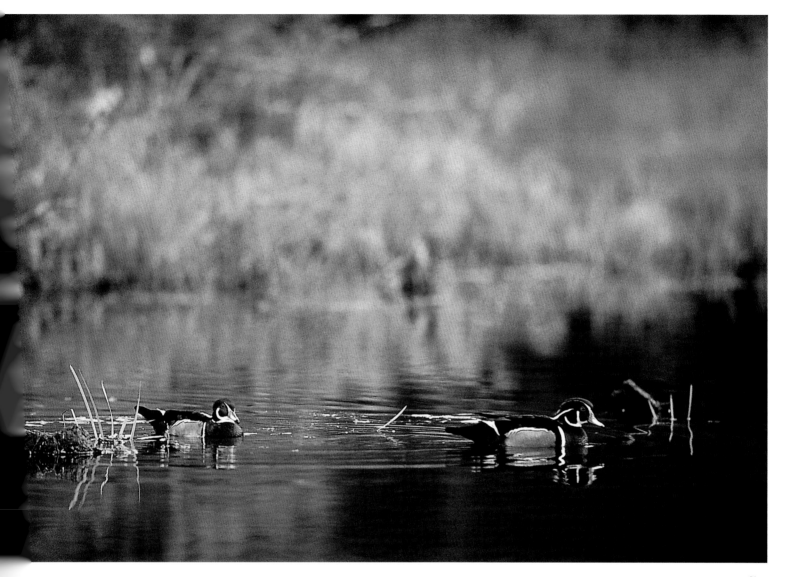

Woodies

The most beautiful of Maine's
waterfowl, male wood ducks
brighten an otherwise dim and
dreary early evening on Otter Stream.

Kiss Me

Floating motionless on the calm
waters of Bugaboo Pond, this green
frog has positioned itself to ambush
any insects that come within range.

Parent's Caress

A juvenile beaver raises its flat tail in
response to its parent's greeting.
Juvenile beavers may remain with
their family group for up to two years.

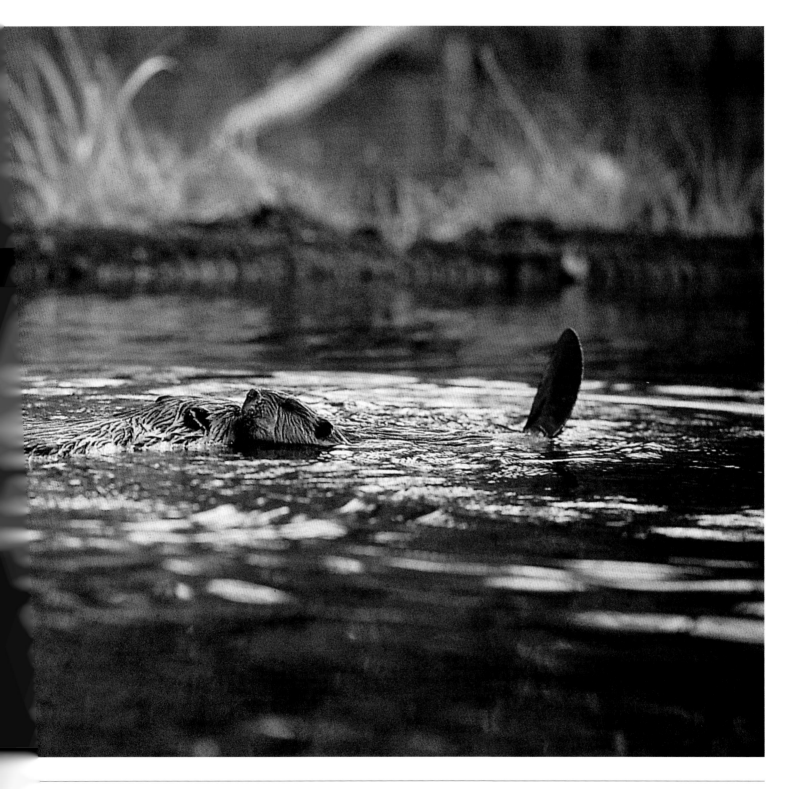

September 30

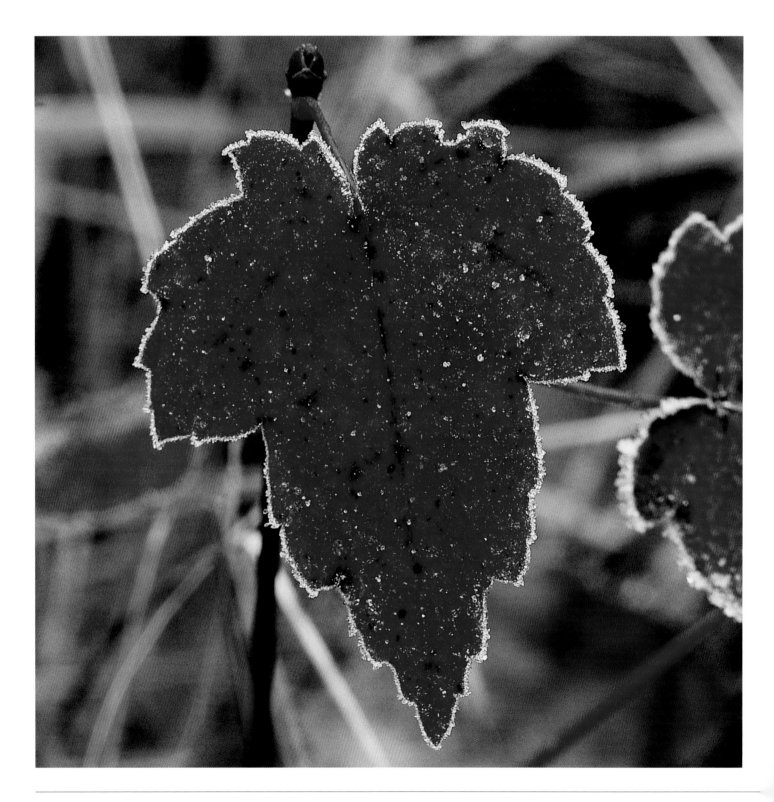

week forty-one

First Frost

Bright maple leaves rimmed
with tiny ice crystals announce
that fall has arrived.

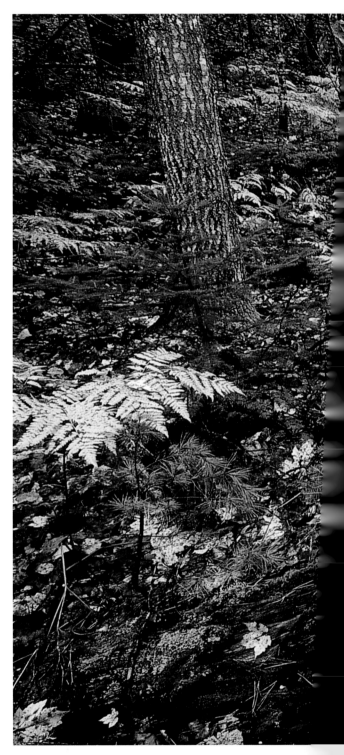

Fall on the Forest Floor

Deep into the fall season, ferns turn brown and
dropped leaves accumulate on the forest floor.
This vegetative debris decomposes to become
an important source of forest fertilizer.

week forty-two

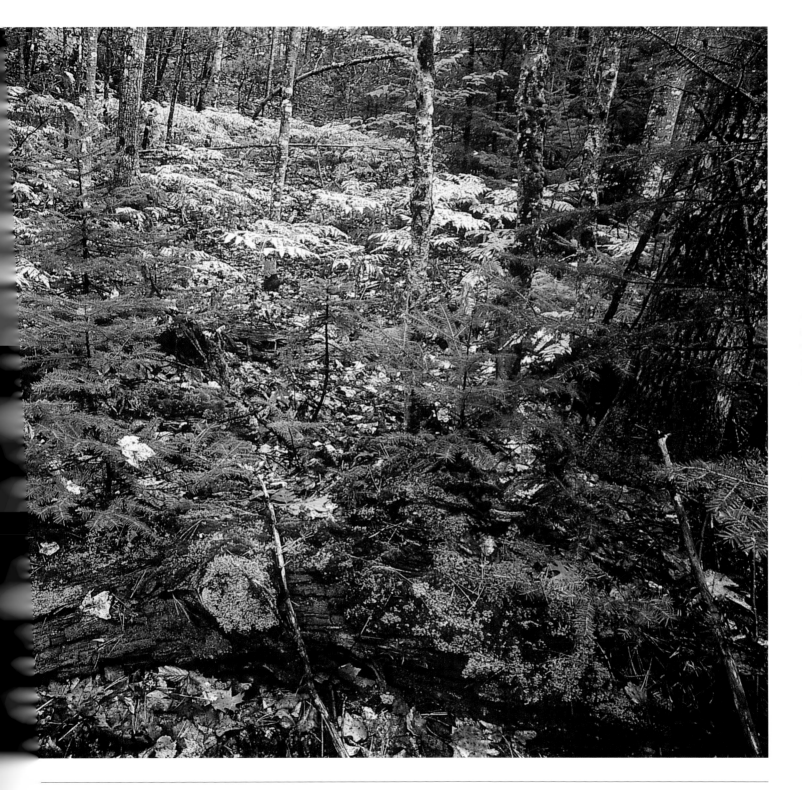

October 15

Tail Feather

A few feathers are all that remain of a ruffed grouse. Was it a coyote, bobcat, or great horned owl that preyed upon the hapless bird? During a typical year, ruffed grouse are an important prey species for a variety of ground and aerial predators.

week forty-three

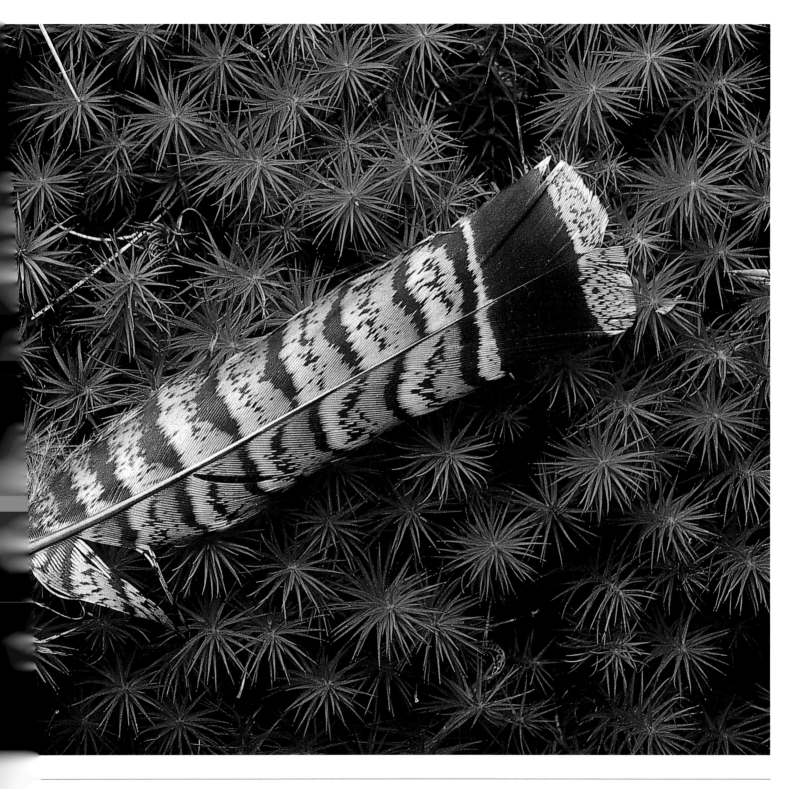

October 24

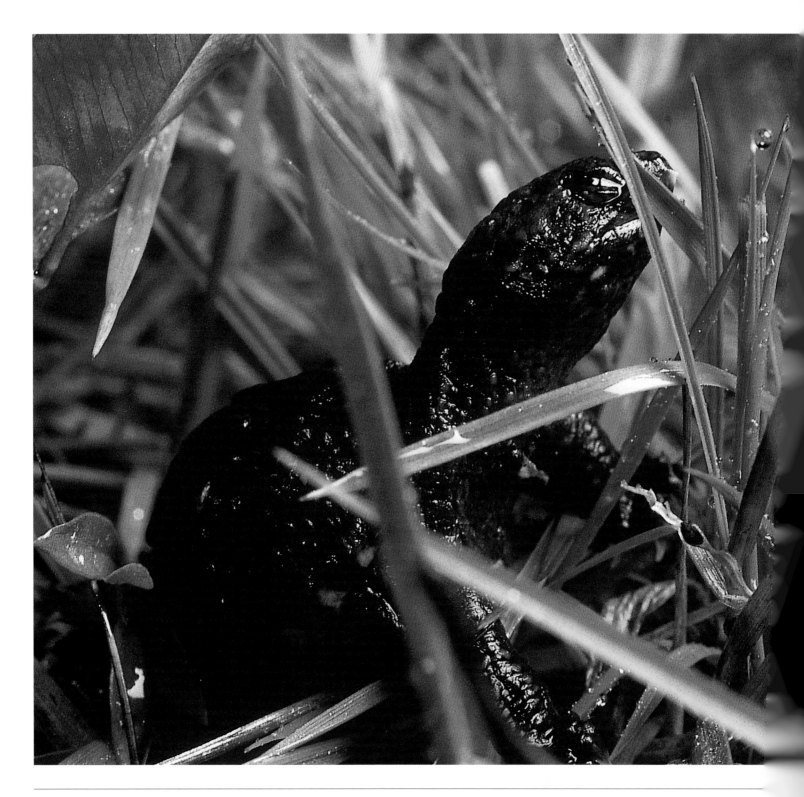

week forty-four

Newborn

Blades of grass appear tree-high to this one-inch snapping turtle that is only hours, if not minutes, old. Digging and climbing out of its nest located ten inches in the ground is an astounding feat. Occasionally, hatched "snappers" overwinter in their nest and emerge the following spring.

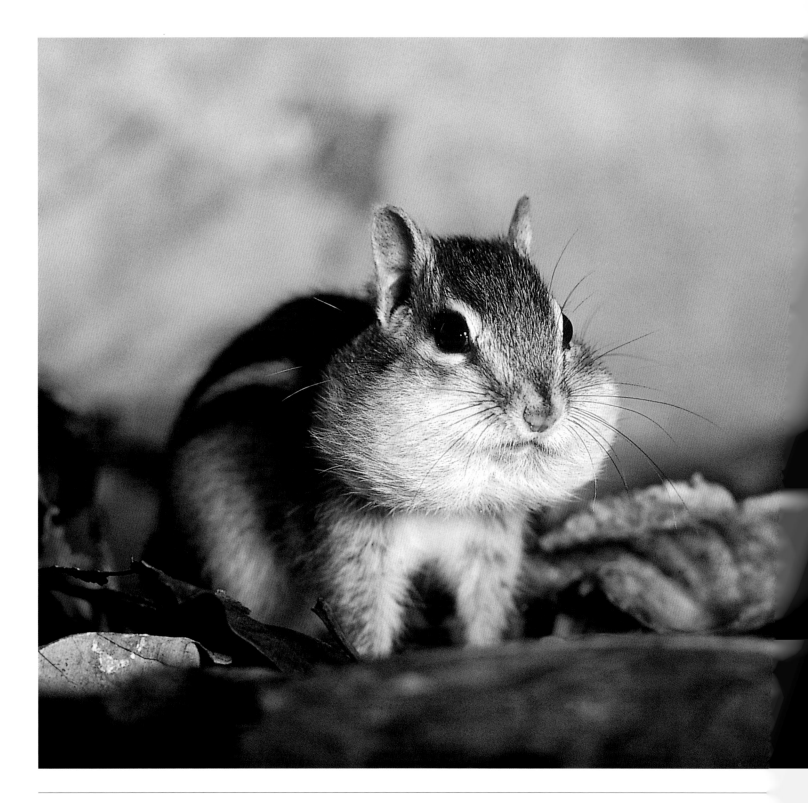

week forty-five

Winter Preparation

This eastern chipmunk's cheek pouches are expanded with seeds that will be hoarded for its meals during the lean months of winter. Chipmunks have been observed carrying six acorns at a time in their cheek pouches. During a research study, one was recorded loading its food cache with 928 acorns in a single day.

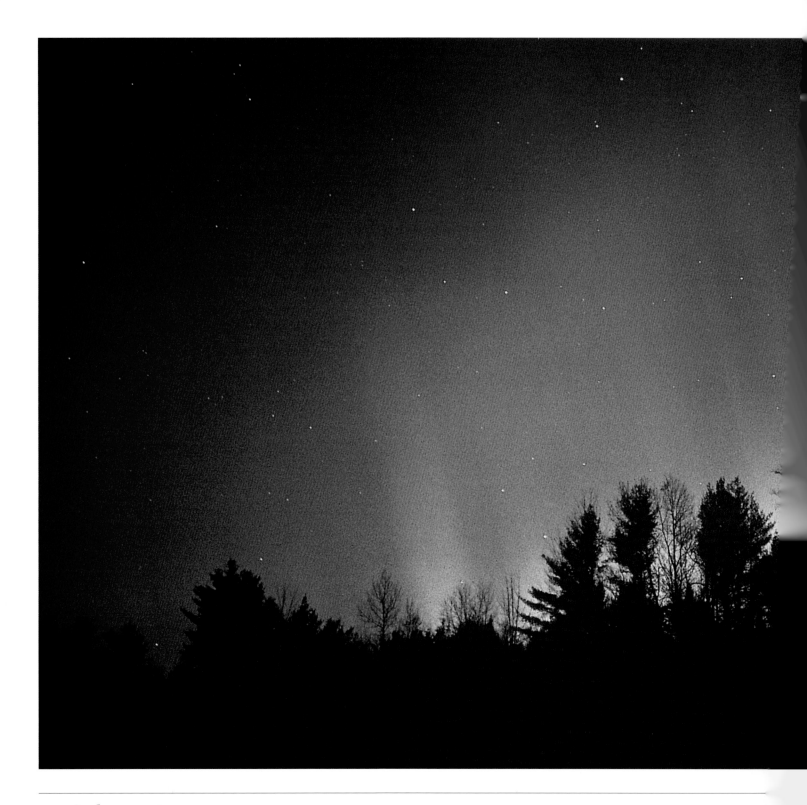

week forty-six

Blazing Twilight

Within a half hour after the weak winter sun has set, a heavenly crimson glow briefly radiates from the western horizon.

Aurora Borealis

A shimmer of the infrequently seen northern lights penetrates a darkened sky at 5 a.m. over the trees bordering Bear Pond.

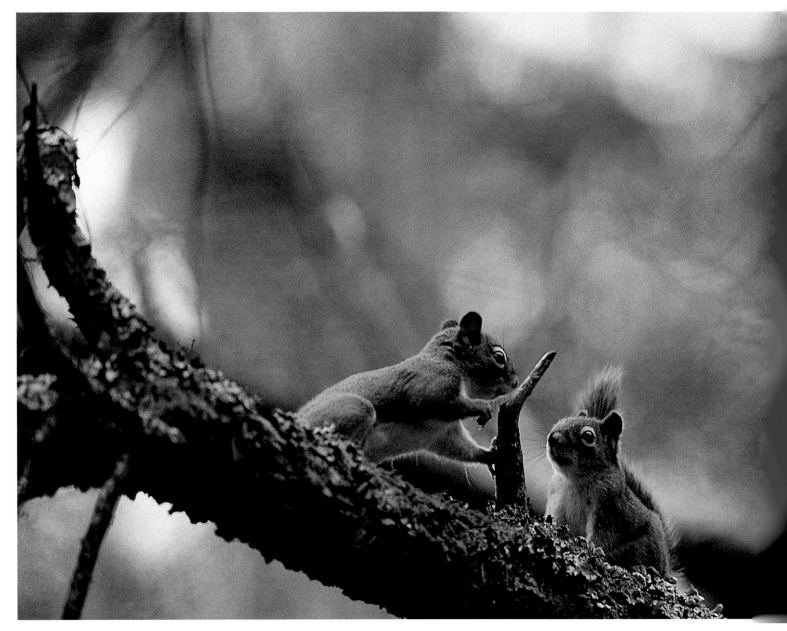

Rendezvous

Red squirrels pause after
nimbly pursuing each
other on a narrow limb
high above the forest floor.

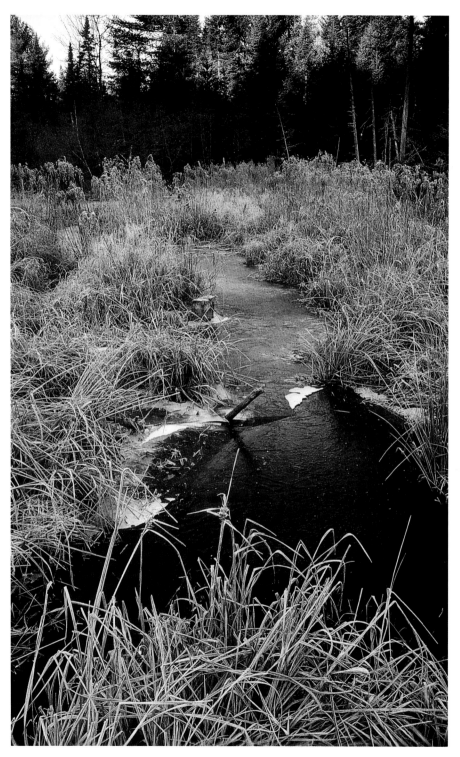

Bugaboo Creek
Signs of approaching
winter glaze the surface of
Bugaboo creek.

Life in Death

The rhythm of life from
death continues with a tiny
sapling obtaining nutrition
from the decaying remains
of a once-thriving tree.

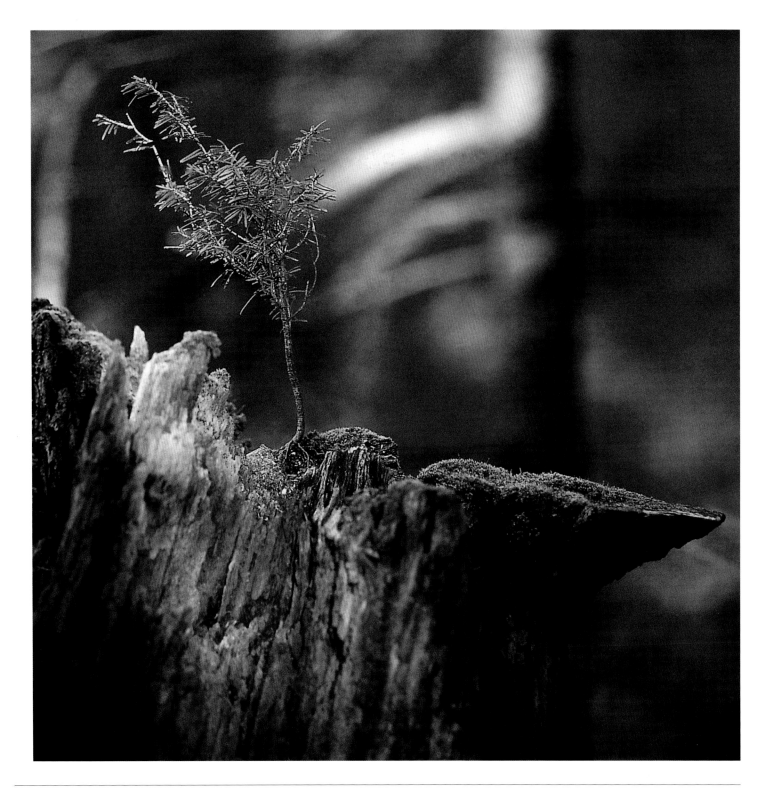

November 27

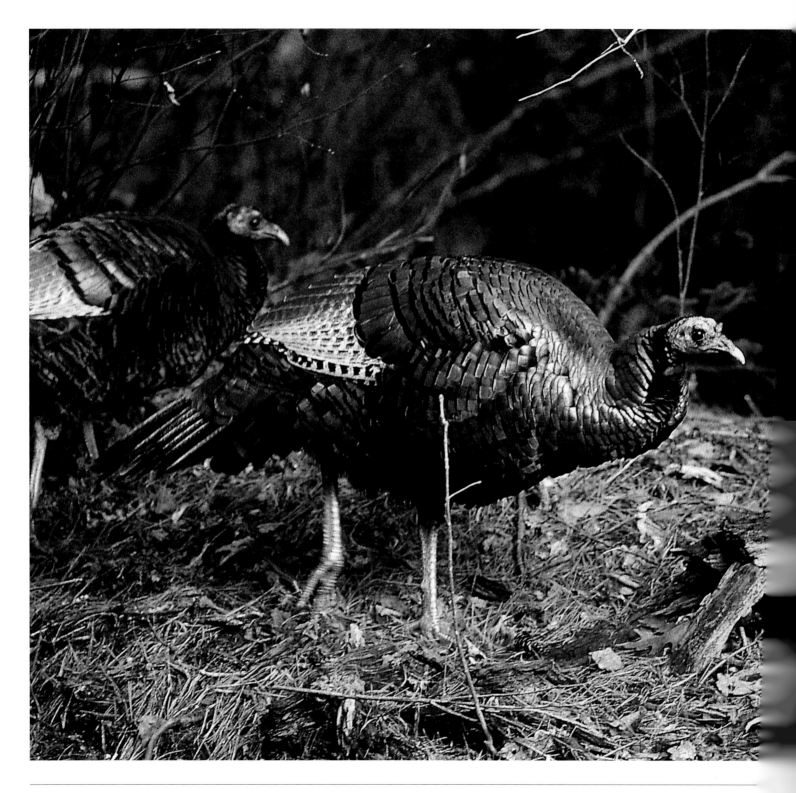

week forty-nine

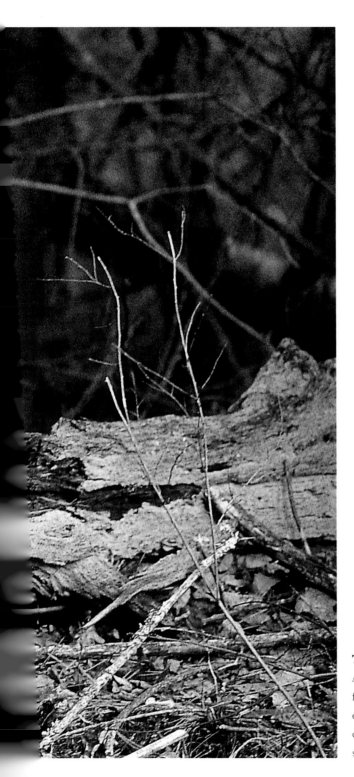

Turkey Troop

A flock of nineteen turkeys ambles out of the forest shadow into a clearing. Wild turkeys were extirpated in Maine before the mid-nineteenth century, but made a remarkable comeback via stocking efforts in the 1970s and 1980s.

Streaking Snow
The first snowfall may only bring
a dusting, but by winter's end
there may be more than three feet
of snow blanketing the land.

week fifty

Nature's Christmas Trees

Ice crystals nearly an inch long
formed on these twigs on a morning
that saw temperatures plummet to
minus two degrees Fahrenheit.

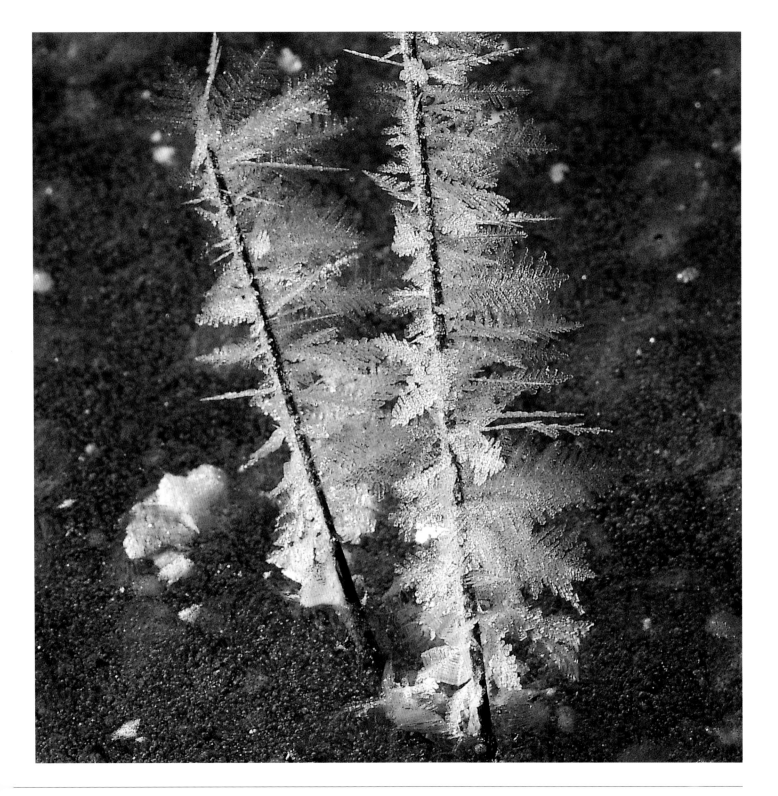

December 16

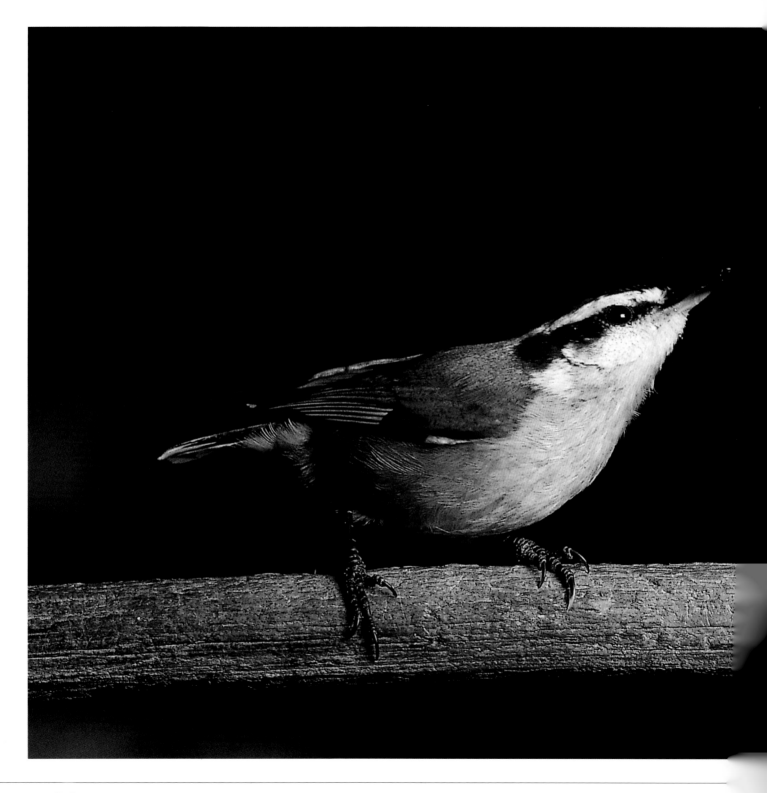

week fifty-two

Red-Breasted Nuthatch

The diminutive red-breasted nuthatch is
a four-season denizen of Maine's forest
canopy. This hardy bird is found in a
variety of woodland habitats, but its
preference tends toward coniferous forests.

East Branch of the Eastern River
Darkness arrives chilly and raw to close
another year on this small Maine river.

week fifty-three

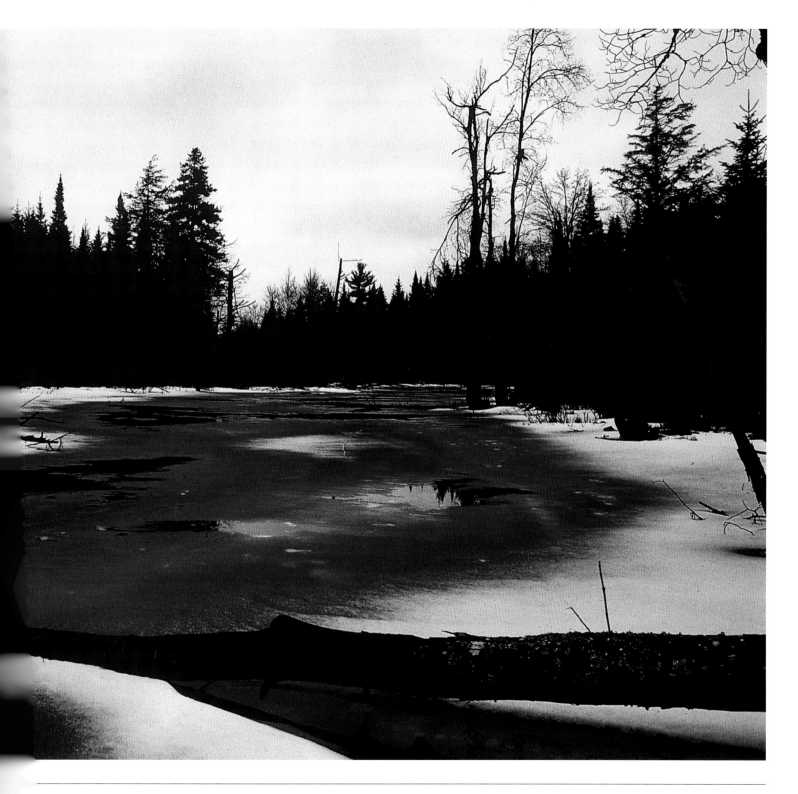

December 30

afterword

Wealth is measured in many ways, most commonly by the accumulation of money and material goods, but my husband, Tom, made me aware of the true richness one can possess. This has, in turn, added immeasurably to both of our lives by allowing us to live and work collaboratively and to enjoy life's simple yet deeply satisfying pleasures.

Until I had my first date with Thomas Mark Szelog, I looked at the world as most of us do and raced through each day on autopilot. During that first dinner together more than twenty years ago, Tom told me about his love of photography. He spoke with a confidence and passion that I had rarely seen before. I was moved by his aspirations and excited by his enthusiasm for his work.

Tom photographed subjects as diverse as orchestras, parades, fires, and presidential campaigns. He enjoyed his work and used every opportunity to tweak his craft, fine-tune his skills, and create art. Although he loved all types of photography, his passion was photographing nature and wildlife.

I began accompanying him on photographic assignments, during which I learned to continually observe my surroundings, regardless of what else I might be doing at the time. Tom encouraged me to look for beauty, especially in the natural world. He taught me to appreciate the warm, low-angle light of sunrise and sunset. If you haven't trained your eye to watch the changing light, I encourage you to do so. Look again at how light enhances the images within this book. You will see the vibrant influence it lends to what are already lovely scenes. Sunlight can illuminate the smallest objects, such as snowflakes, and make them a magnificent part of the photographic canvas. A setting can become saturated with color for a few beautifully lighted but fleeting moments; hence the importance of opening one's eyes to the artistry that unfolds from minute to minute.

Tom broadened my vision to encompass the simple, delicate details that surround us, but that, sadly, most of us never take the time to see. Details such as ice crystals adorning grass, milkweed seeds as they blow in the wind, the colors of a blue jay, the sparkle of dewdrops struck by the first rays of sun. Now, thanks to Tom, I embrace the beauty, the tranquility, the simplicity of each day.

Tom's interest in wildlife began at an early age, when as a youngster he walked several blocks from his Manchester, New Hampshire, home to the banks of the Merrimack River to observe wildlife. Inspired by his sightings, he began keeping personal journals about his wildlife encounters. There beside the river, sitting quietly and unseen with all his senses awake, he felt himself to be in another land. Surely this was the start of his appreciation for the natural wealth in his own backyard.

When Tom was in his teens, his older brothers introduced him to hunting. Wanting to make his brothers proud, he shot a woodchuck, then cried over his kill. He

put down his gun for good, and soon began hunting with a camera instead. Over time, Tom's explorations took him farther into the woods. Bear Brook State Park in Allenstown, New Hampshire, became one of his favorite locations; he explored the entire park and absorbed its beauty. This place took on such meaning for him that, years later, he named our log cabin after it.

The road has been long and winding and filled with many potholes, but through it all Tom has remained focused on his vision. This book is a reflection of his life-long love and respect for nature. What you see within the pages of *By a Maine River* reflects the person Tom is. When people comment on the beauty of his photographs, Tom often responds in jest: "When you shoot as much film as I do, sometimes you get lucky." Perhaps luck plays a certain role in all of our lives, but I know that Tom concentrates on enhancing his art every day and has done so for the past thirty years. He reads constantly, studies the art of photography, and applies new skills and knowledge to improve his product. A contributing factor to the uniqueness of his wildlife photographs is the patience with which he acquires them. Rather than stalking his subjects, he waits unobtrusively for hours—sometimes days—for his subjects to approach him, so he can capture their naturally occurring moods and behaviors.

There are two loves (besides me) in Tom's life: wildlife/nature photography and the Boston Red Sox. Before this project, if you had asked me which he loved most, I would have been unable to say for certain. I can now answer that question as a result of an experience that occurred during the year when he was creating the images for this book.

If by Sunday of each week he did not yet have a good photograph, the pressure was on Tom to produce. One such Sunday was October 24, 2004, the second game of the World Series at Boston's Fenway Park. We had inquired about obtaining tickets to one of the games but never thought we'd get them.

However, on that Sunday the phone rang around noon, when Tom was getting ready to venture out to obtain his much-needed photograph. "How quickly can you get to Boston?" my cousin Janet asked. "There are two tickets for tonight's game waiting for you."

At that moment, Tom and I felt as if we'd won the lottery. But what about the photograph for this week? Our exuberance faded quickly as Tom's work ethic took priority. It was then that I realized Tom's dedication to photography comes first, even before the Red Sox playing a World Series game at Fenway. I encourage you to take a second look at the simple but elegant photograph made on October 24, now that you know the story behind it.

(And we did make it to the game. Tom obtained his photograph; then we drove to Boston and arrived at the stadium in time to devour a Fenway Frank before the first pitch.)

Tom also has taught me the importance of being true to myself, to live from my heart. Again, he taught by example: Tom creates nature photographs because he loves doing it, which is another way of saying that they come from his heart.

Whether by fate, perseverance, or plain good luck, Tom and I have been truly blessed. We cherish the experiences presented to us and appreciate the wealth our natural world provides. As some readers know from our first book, *Our Point of View: Fourteen Years at a Maine Lighthouse*, Marshall Point Light is our past. Bear Brook Cabin is our present. And the best is yet to come.

May you find inspiration to pursue your own dreams as Tom and I have pursued ours in a log cabin by a Maine river.

Lee Ann Szelog

afterword